MW00460859

the *snow* unleashed

A MOM'S 40-DAY DEVOTIONAL

the *snow* unleashed

ABIGAIL HARRISON

MAPMAKER PUBLISHING

Copyright © 2017 by Mapmaker Publishing
All rights reserved. This book or any portion thereof
may not be reproduced or used in any manner whatsoever
without the express written permission of the publisher
except for the use of brief quotations in a book review.
Published in the United States of America
First Printing, 2017

Scripture quotations taken from the New American
Standard Bible® (NASB),
Copyright © 1960, 1962, 1963, 1968, 1971, 1972, 1973,
1975, 1977, 1995 by The Lockman Foundation
Used by permission. www.Lockman.org

Cover images from Shutterstock.com

Cover design by Roseanna White Designs

ISBN: 978-1-947912-00-7

For more check out: www.laneigeunleashed.com

For Virginia Alice Rodman, my great-grandmother—she never stopped loving. Her love started me on a journey to unconditional, and I will never be the same.

Devotions

But first...

This book comes out of a deep place in my heart—a place of surrender as I laid down the parts of my life that didn't work and exchanged them for the life abundant (John 10:10).

Sometime after I got married in 2009, the Lord gave me a dream where I saw my children. So vivid and real, I knew I would be having a girl and a boy approximately a year apart. When the Lord prompted my heart to start our family, I quickly suffered the heartbreak of a miscarriage. Devastated, I lay crying on the floor and distinctly heard the Lord say, **"You cannot lose the children I have for you."**

Because He spoke to my heart that day, I cast my fear aside and trusted Him with the crazy that followed. Two kids, eleven and a half months apart, grew me in the Lord in ways I didn't know possible.

A few months after my son was born (my second child), the Lord spoke to my heart. He impressed upon me to start a fitness group. Fitness and motherhood are two places in our lives where we tend to be vulnerable. The Lord wanted me to combine the two and allow people to see the process of my growth. Beyond nervous, I couldn't imagine having the time or energy to give any more than I was already giving. It required great trust from me, but as I leaned in, every day, He gave me a word to cling to for the day.

My goal in writing this book is to light a yearning fire in your heart to know God and be known by Him. Allow yourself to search the deep places of the Lord's heart and grow in this season the Lord has called you into— Motherhood.

This is not your typical devotional. It's created for moms who want to go deeper with God but struggle to find the time. I've tried to keep it succinct and time–friendly. I've put a lot of information into a short period of time. Feel free to take a few days or even weeks on a devotion that the Lord highlights to you.

There will be days you do not feel the devotion applies to you. We are each going through different seasons. Put it aside and continue on; it might be something that speaks to you in the next season.

Each devotional is broken down into six parts:

- **Scripture to mediate on**—moms do not have a lot of time to sit around and read scriptures all day, but we are capable of mulling over one throughout the day. Write it down; read it over and over again as you change diapers, work your job or make meals; and ask the Lord what it means to Him. Chew on the words – these words of life will sustain you. All scripture references in this book are from the *New American Standard Bible* for the sake of understanding and continuity.
- **Suggested chapter of the Bible**—sometimes when we open our Bibles, it's difficult to know where to start. This will help you jump into the Word and be transformed by the renewing of your mind.
- **Body of the text**—a hopefully thought–provoking anecdote mostly from the realness and vulnerability of my own life.
- **Questions to bring before the Lord**—Take this time to ask the Lord some questions. He loves to answer and speak.
- **Application**—a way to apply what you just read into your daily life.

- **A closing prayer**—Communicating with God is so essential. Sometimes, we do not know what to say. This will help you start the conversation.

The Meaning Behind the Name

At 14 years old, I had the opportunity to visit Paris, France. Pause for dramatic effect because what young girl that age isn't dramatic. And as you can imagine, an impressionable teen in Paris, I fell in love! Fortunately for me, it was only with the language.

I named my fitness group "La Neige au Sahara" which means, "Snow on the Sahara" in French. It references something rare and seemingly frivolous. Snow on the Sahara doesn't happen very often but when it does, it is breathtaking. After a snow, beauty comes forth and everything gets a drink. The beautiful but frozen ice is not the end product. I liken it to unconditional love. How often have we met a person who truly loves unconditionally?

My goal is to be this person. The Bible says love never fails. I've made it my mission to prove this scripture. Unconditional love can feel pointless when you first adopt it as a way of life, but that's because it was always meant to melt on the surface then go deep.

A few years later, my great-grandmother took me into her house during a tumultuous period of my life. My parents' crumbling marriage put me into crisis. My great-grandmother never acted bothered by the angry, messed up 16–year–old but daily poured her love into me.

Her love softened the hard places and transformed my life. My parents' marriage recovered, and because of the transfusion my own life had received, I'd journeyed to a place where I could forgive and love again.

I love the phrase "La Neige au Sahara" because it applies to so many other things in life. Exercise, child raising,

housework— they can all seem like an exercise in futility, but none of our efforts are wasted. Each push of our heart is being recorded. Each time we make the right choice towards a more disciplined lifestyle, we grow stronger. Nothing is wasted.

I truly believe one day we will stand before God and He will ask, **"But did you love?"** (Matthew 25:31–46) The measure of Christ's love we have allowed to be formed in us will be all that matters.

Mommy Health Tips

Your Body is a temple! In an effort to help you take care of the complete temple, I've compiled a few of my favorite health tips. My goal is to be healthy. I find when I focus on weight loss, I become unbalanced, but when I focus on health, weight loss is a natural consequence. Our intentions are very powerful. Decide what is doable for you and dedicate these changes in your life for a full week. Write down how much better you feel at the end of the week.

- **Water**—This is the quickest way to be healthy and lose weight. Scientific research says our bodies often confuse being hungry for actually being thirsty. You should drink half your body weight in ounces every day. Example: If you weigh 140 pounds, drink 70 ounces of water every day. Fast facts:
 - Dehydration is a rampant problem.
 - Proper intake of water hydrates your skin; it will create that glowing complexion you long for.
 - A good cheat is to drink a giant glass of water (2-3 cups) 10–15 minutes before your meal or snack.
 - You might feel bloated for a day or two because of systemic dehydration.
 - Your throat may feel dry or sore for the first few days. This is normal and goes away.
- **Sugar**—Try to cut out all excess sugar. If soft drinks are your problem, drink fizzy non–sugary drinks instead. I like carbonated water and it helps me curb the habit.
 - Most sugar is not good for you. The Bible even talks about it. Try substituting sugar for local honey.

- o Sugar detox can be painful like kicking a chemical dependency. Remember you are a strong momma. You are making this change for you and your family. You are most likely (statistically) the gatekeeper of their nutrition.
- **Protein**—Protein is so important for muscles and strength. I find a protein shake in the morning after a workout can make all the difference. Look for one that has added benefits like "greens." Avoid sugar or soy products. Blend it with a little fruit to up your fruit intake and make it delicious.
- **Vegetables**—You can never eat too many. (I mean you can, for the purpose of legal argument, but you catch the drift.) My favorite right now is oven–roasted vegetables. Try lightly coating vegetables in olive oil and throwing them in the oven for twenty to thirty minutes at 450 F.
 - o A good vegetable goal is five cups of veggies throughout the day. Water + the fiber from fruits and vegetables will feel like a life changer.
- **Fruit**—Try to limit fruit to the morning. Our bodies have an easier time processing and burning fruit in the morning.
 - o A good benchmark is no more than three cups per day. You can get what's in season, or you can be like my husband who loves to snack on blueberries and blackberries. It keeps him both calm and alert to have something to munch.
- **Snacks**—I love good fats and as a mom, they're a great go–to when you need quick energy. Try using hummus or guacamole as a vegetable dip.
 - o Moms know they need a few extra calories building the baby or the milk stores for breastfeeding (no shame if you don't breastfeed).

- **Chocolate**—For those times when nothing else will do. I suggest buying dark chocolate baking chips and eating a few at a time. I believe in desserts in moderation. There is nothing wrong with dark chocolate. If you're going to enjoy something sweet—truly enjoy it. Learn to savor every second; do not eat it mindlessly.
 - Let's face it. There's always some research saying how good it is. While that's most likely true, like all things we have a tendency even in moderation to overeat it. Portion it out beforehand so you do not go overboard.

Day 1

Focus Scripture: "Do you not know that those who run in a race all run, but only one receives the prize? Run in such a way that you may win. Everyone who competes in the games exercises self–control in all things. They then do it to receive a perishable wreath, but we an imperishable. Therefore I run in such a way, as not without aim; I box in such a way, as not beating the air; but I discipline my body and make it my slave, so that, after I have preached to others, I myself will not be disqualified." 1 Corinthians 9:24–27

Scripture Reading: 1 Corinthians 9

Mom'in Ain't Easy

Barely a few months into being a mom, I realized the untapped spiritual potential of motherhood.

I had entered into a new phase of my life where my life no longer belonged to me. A child depended on me for everything. I felt alone, drained, and frankly, scared. My life had quieted down, and everything seemed so terribly isolating.

I soon became desperate for a God encounter, and He was more than willing to meet me. This was the perfect atmosphere for God to work. Sometimes the cave (hidden away, disconnected from the world, prison) is where God meets us.

As I spoke with my mom-friends, I realized I wasn't alone. They knew that pain and felt just as cut off from society as I did. Babies can be so tricky. As long as they're happy, everyone wants to hold them, but when they fuss, people find them inconvenient.

Many of my mom-friends felt they couldn't take their children out to church functions that didn't have daycare because the baby might be a disturbance to those without children.

During this period of time, I learned I needed more discipline, and God remained faithful to teach me. Sharing my life, alone, required a schedule. If you're like me, coping with the first kid doesn't change your life that much (though at the time it feels like it does), but by the second, I

11

realized that I needed a system. Here are a few things I found helpful:

- **Listen to sermons, praise music and scripture:** This time of your life is extremely draining but can actually be an incredible time of drawing close to the Lord. In the monotony, build your spirit! You will not regret the time spent drawing closer to God, and you will be able to reach more of your full potential. Your smart phone has so many cool apps. We have no excuses for how our time is spent. Bonus perk, you are changing the atmosphere of your home and your child will respond in kind to this peaceful environment. My kids are so much calmer when we listen to praise music.

- **Set a flexible schedule that works for you:** I knew I wanted to prioritize my marriage, and from what I read in books, kids need twelve hours of sleep each day, so I arranged my kids' sleeping habits around spending quality time with my husband who appreciated it. My kids are well adjusted in sleep. This takes practice so do not be upset if it doesn't work immediately. Decide on a goal and work towards it. Because of my goal for my children to be well rested, I made active choices to encourage sleep, like scheduling naptimes and staying home during these times. The practice applies to a lot of parenting. We have to get with God and our spouses to figure out what it should look like and then have the discipline to set up successful habits.

- **Reach out to other moms:** Talking to other new moms, you will realize that parts of your story aren't unique. Nobody has the same experience, but everyone tries to be a good mom. Work on building a community. You could start a prayer meeting,

have play dates or encourage each other at grocery stores. The Body of Christ needs each other. It isn't good to isolate yourself. Find moms and build them up.

Questions: Do you feel like your schedule works for you? Would you know if your mommy friends are struggling?

Application: Find your local park and make it a point to casually say "hi" to at least one new mom every time you go. That little bit of effort to reach out to another mom could make a huge difference in both of your lives.

Prayer: Holy Spirit, today I ask that You send like–minded moms into my path. I ask for boldness to connect with them. Lord, give me wisdom in this season. I need to know how to make the most of this time. Help me grow in discipline. I declare that You give me success in all that I am called to do. As I open my mouth, You will fill it with words of encouragement. You have placed in my heart to build other moms up. Teach me to be a fount of encouragement.

Day 2

Focus Scripture: "For you have need of endurance, so that when you have done the will of God, you may receive what was promised. FOR YET IN A VERY LITTLE WHILE, HE WHO IS COMING WILL COME, AND WILL NOT DELAY. BUT MY RIGHTEOUS ONE SHALL LIVE BY FAITH; IF HE SHRINKS BACK, MY SOUL HAS NO PLEASURE IN HIM." Hebrews 10:36–38

Scripture Reading: Hebrews 10

"Don't Stop 'Til You Get Enough!"

Let me point out that the song isn't "Don't stop 'til you have <u>had</u> enough."

One day, I woke up grumpy to a day that appeared less than stellar. My mom challenged me to choose to have a good day. I agreed and all hell broke loose. Kids were in shambles. Rain was pouring. People weren't working with me and unexpected major problems (I had to call an after–hours emergency plumber). Intense, I tell you!

***Side note: Don't tell God you are choosing to have a good day if you don't mean it.

I had recently watched a few episodes of a reality TV show that sells houses and in those particular episodes the realtor told the couple that it was a multi–offer situation and they should go in with their best offer. He then came back and said they won because their offer was 1–2 grand more than the other offers. When you are buying a several-hundred-thousand-dollar house, a few grand is not a big deal.

I was sitting on the couch thinking of how hard I have been pushing against an imaginary wall all day when God started speaking to me. He reminded me of those episodes and said, **"Do you know how many people miss their breakthrough by 1–2 grand?"**

I was reminded about a day I spent as a teenager fasting and praying. I decided I was going to spend a day in the woods with God because I needed answers. Let me tell you, not even the birds chirped that day. The heavens seemed

15

silent, and I was miserable. I felt hoarse after all the talking and begging.

I went home, and my mom said, "God told me He was enjoying spending the day with you."

Yeah, it kind of made me mad because I was disappointed that He didn't meet me exactly when I sought Him, but that night, God started speaking to me and wouldn't stop.

If you need a breakthrough, don't stop until you get enough (and frankly, when it's God, it's never enough and yet always plenty). It's coming! Keep walking it out. Set your face and seek His heart every morning. This is going to be a great day!

Questions: Do you find yourself in need of a breakthrough? Are you struggling with the same problems over and over again?

Application: Look over your life and decide if you are satisfied. Endurance is rewarded both in Heaven and on earth. What has God promised you? What has He written on your heart? How many parts of your life are you ready to give up on? Should you? If you want something different, you have to be different. Let the Lord reveal to you what His plan is and how to endure until the promise. He will teach you how to win—all you have to do is ask.

Pray: Dear Heavenly Father, give me endurance for this day. Show me what is attainable and help me push until I reach it. Lord, I want to be known for the measure of You I have allowed. Thank You for Your goodness. I come into agreement with the Word when it says that as I call upon You, You answer me. I am blessed with all spiritual blessings in heavenly places in Christ Jesus (Ephesians 1:3). Lord, I know that I am strengthened with might by

His Spirit in the inner man (Ephesians 3:16). Thank you, Father, for being so good.

Day 3

Focus Reading: "How then will they call on Him in whom they have not believed? How will they believe in Him whom they have not heard? And how will they hear without a preacher? How will they preach unless they are sent? Just as it is written, "How beautiful are the feet of those who bring good news of good things!" Romans 10:14–15

Faith Comes by Hearing

One of the most exciting truths about God is that He still speaks to His people. He still tells us His heart. We get to learn what God's voice sounds like. We are privileged to share our hearts with Him and get actual answers. We all hear voices inside us—sometimes it is God, the devil (adversary/accuser) or our thoughts/our flesh.

We have to read the Bible so we can determine what God sounds like. When we read the Word, we can accurately measure what we hear and decide if it comes from the Father's heart (John 10:27). The definition of faith is "complete confidence or trust in something or someone."

Many people do not believe they can hear the Lord. They go their entire life thinking they never hear a word He says. Many others confuse another source as the voice of the Lord. How can you be sure you are hearing God? Here are a few of my favorite tips:

- **The Voice lines up with God's character.** If you spend time in the Word meditating on Jesus, you will start seeing patterns. Jesus did not give people cancer—He took it away. He did not hate, but He loved. He did not speak in problems but solutions. GOD WILL NOT TELL YOU ABOUT A PROBLEM! (Galatians 5:1; John 10:10)
- **Time will prove it to be true.** If you think you heard something the Lord said, write it down. You will learn to discern and follow His voice with accuracy. He will give you short tasks to complete. The Lord loves to train us to hear His voice. He will

not condemn you if you mess up. There is a grace to hear His voice (Hebrews 11:1).

- **You will receive confirmations.** The Lord will send "waymarks" telling you that you are on the right path. "Your ears will hear a word behind you, **'This is the way, walk in it,'** whenever you turn to the right or to the left." Isaiah 30:21. The voice is behind you because you are walking out your life.
- **You will seek Me and find Me when you search for Me with all your heart. (Jeremiah 29:13).** This is pretty simple —if you want to hear Him, you will. Get alone with God and learn to live in His presence.
- **He will show you things to come (Jeremiah 33:3).** The Lord knows what your future holds. He will often give you dreams, visions or words so you can be prepared. The Lord has often warned me not to do something or that something was coming. It's one of the beautiful perks of being a child of God. "And He said, 'To you it has been granted to know the mysteries of the kingdom of God, but to the rest it is in parables, so that SEEING THEY MAY NOT SEE, AND HEARING THEY MAY NOT UNDERSTAND.' " Luke 8:10

Question: Have you ever heard God speak?

Application: He is not trying to hide from us. Ask Him to speak and then spend time listening. Write down what you think He is saying. Ask Him to train you to hear His voice. Spend a few minutes each day writing down what the Lord is saying and teaching you.

Prayer: Heavenly Father, thank You so much that You do not hide Yourself from us. Thank You that You want to be known by us. Teach us Your voice. We want to pray prayers that are effective. We want to receive feedback

from You. Lord, the Bible says You alone are a good Shepherd and Your sheep hear Your voice. We love Your leadership. God, I ask that You speak to me. Lord, I take the time to clear out all distractions. I want to focus on You. Lord, Your Word says I have favor with You. Thank You that You desire relationship. I am so blessed by Your love.

Day 4

Focus Scripture: "Blessed are the peacemakers, for they shall be called sons of God." Matthew 5:9

Scripture Reading: Matthew 5

Go Lower, Go Slower . . .

When I first heard Mozambique missionary Heidi Baker speak these four words, the Holy Spirit lit a fire inside me and started revealing how this was a part of His nature.

These words have changed my parenting and life in every possible way. I have not run across a problem yet that they do not fix. My interpretation of it is "go lower—a humble face bowed towards God will fix all problems; go slower— react with calm and patience. Good things will follow."

This is an invitation for Christ to take over your life and problems. The door is flung open for Kingdom to invade. Calmness rises in your spirit to face the problem when these words are adopted. Your life goes smoother, and you don't feel as taxed by the onslaught of the day.

Let me give you some hypothetical examples:
- Kids are wearing me down. I have a five-hour drive with them by myself. My kids take my lead on how to react to stressful situations. I can exasperate the situation, or I can calm it down. I've learned that there is no point in getting myself worked up. Just calmly take it as it comes and respond in a Christ– like manner.
- My husband and I have a tiff. Quite clearly, I think he's wrong, and he didn't handle the situation as well as I think he could have. Go lower, go slower. No matter if he is completely wrong, I have to be like Christ. I must go lower and sort the problem out humbly. If I fight, I am just as wrong as he is. God will move on both of our hearts if I allow Him.

- I'm having a hard time meeting my goals—I think I should be running further by now, but my pushing has almost caused an injury. Go slower. Be patient with myself. I must allow my body the chance to catch up.

It seems counterintuitive, but if you let this take over your spirit, you will be as revolutionized as I am.

Questions: Do you struggle with patience?

Application: Every time a situation arises, say to yourself, *Go lower, go slower.*

Prayer: Lord, I am so grateful for my family. Thank You that You are more than enough for me today. Lord, help me walk out my day in a loving manner. Help me to remember who I am. I am a child of the King and I have everything I need pertaining to this life and Godliness at my disposal. I am the head and not the tail (Deuteronomy 28:13). I am the righteousness of God in Christ (2 Corinthians 5:21). Teach me to walk humbly before You. Thank You for what You are doing in my family. I want to be effective.

Day 5

Focus Scripture: "My sheep hear My voice, and I know them, and they follow Me; and I give eternal life to them, and they will never perish; and no one will snatch them out of My hand. My Father, who has given them to Me, is greater than all; and no one is able to snatch them out of the Father's hand. I and the Father are one." John 10:27–30

Scripture Reference: John 10

How to Hear

When I was pregnant with my first, my husband worked in the oilfield. My hormones were going wild, and I was very freaked out that he wouldn't be home from his job in time to witness the birth of our child. My husband hears the Lord differently than I do. He sometimes hears dates and timelines, whereas, I never do. (I tend to lean more on the prophetic and discerning spectrum.)

When he prayed, he heard our child would be born August 22nd. The date came and left, and I was pretty discouraged. I was ready to have this baby. Little did I know, I would be pregnant again quickly and have two kids who had the same due date. When the time approached, I believed the Word of the Lord my husband had spoken. I was sure that my son would be born on August 22nd and he was.

Today, we are going to talk about how God speaks. Everyone desires encounters with our Father, and we have to be open to hearing God in many different ways.

- **Audible**—Rarely happens. But super awesome when it does.
- **Still small voice**—Some people call it their conscience, but it is so much more than that. It is a voice that speaks into your spirit.
- **Vision**—There are several kinds of visions but the main thing is, you are awake and you see something from God whether it is with your eyes or in your mind's eye. Sometimes they need to be interpreted just like dreams.

- **His Word**—God loves to speak through His Word (Bible). Jesus is the Living Word (Revelation 19:13 "He is clothed with a robe dipped in blood and His name is the Word of God.") It is a living entity. It's not just about the pages or the text. It breathes and it is still valid for today.

- **Dreams**—Often marked by the fact that they are vivid and you remember details. If you have a vivid dream that you remember, start asking God what it means. To tell you how serious dreams can be, I met my husband because of a dream. I had an option between living in two different places, and I chose the one in my dream because I knew that was where God wanted me.

- **Prophetic**—Sometimes other people hear a word over your life. Always weigh it with the Bible. Remember God doesn't speak in problems, only solutions. So if someone is telling you how horrible you are, it isn't from God. He sees you as covered by His blood (Ephesians 1:7). He sees you as amazing.

- **Angels**—Sometimes He sends angels unaware. I have met several people in the course of my lifetime that I just couldn't explain the transaction that took place.

- **Impressions**—Sometimes God drops something into my spirit, and I suddenly know something I couldn't know. It's like having a calculus manual downloaded into you and all of the sudden being able to do upper level math. You instantly know that something has changed.

- **Circumstances**—When God shuts a door, no man can open it. Sometimes God speaks through situations. This one can be a little tricky. It can be hard to know if the door is shut because it's an attack or if God is protecting you from something. The easiest way to tell is to ask God to reveal Himself and open or shut the door according to His will. Sometimes, we

walk in God's will simply by following openings He has for us.

- **Peace**—The Lord often speaks and leads through peace. When we diligently seek Him, He makes clear the path we are supposed to be on. A supernatural peace will flood your spirit. If I feel uneasy about something, I know to check in and get to the root of what is going on.

God likes to take us through seasons where He teaches us to hear a different way. Be open to multiple ways! Hearing God, and it coming true is one of the most life–giving feelings.

Question: What are some of the ways you have heard/hear God?

Application: Write a list of all the ways you have heard God. Ask the Lord to speak any way He wants to. Over the course of your relationship with Him, He will reveal Himself in many different ways. Do not become set on one way!

Prayer: Lord, I thank You that You are capable of getting the job done. You are quite capable of making Yourself heard. Lord, I listen. I truly want to hear Your voice. Teach me to walk with You. I'm grateful that I walk in the light as He is in the light, and the blood of Jesus cleanses me from all sin (1 John 1:7). Thank You that I have the opportunity to dwell in the secret place of the Most High. I am allowed to abide under the shadow of the Almighty (Psalm 91:1).

Day 6

Focus Reading: "The words of a man's mouth are deep waters; the fountain of wisdom is a bubbling brook...Death and life are in the power of the tongue, and those who love it will eat its fruit."
Proverbs 18: 4;20

Scripture Reading: Proverbs 18

Prophesy

Before I physically became a mom, God gave me a vision. I saw a book in my mind's eye. The Lord revealed to me that it was my unborn daughter's book. He told me that every time I spoke about her, I was proclaiming things that had the power to change the course of her life. When I spoke God's words (prophetically) over her out loud, those words were marked down in the book. I knew my words would play a huge role in her spiritual, emotional, and physical development.

God, then, showed me other people's books—some were fat and overflowing while others were remarkably bare. Some books were personalized, well-worn, stuffed with words and extra pages while other books looked like they had just been purchased with a few half-thoughts written and then discarded. He told me it was also my job to not only speak the words of life over my kids but fill the books of other people as well.

Words change everything. They have the ability to cut or heal. It is our job as Christians to ask God how He feels about someone He has put on our heart and start speaking those words over him or her. God wants us to partner with His heart about people. We will see dramatic changes when we start speaking the truth into their lives of how God feels about people. God spent several thousand years prophesying His own Son into being.

Names are extremely important. Every time you say your child's name, you are prophesying the meaning of the name over them. You are declaring your child's future over and

over again. God told my husband and me that our daughter would be strong and a blessing—that she would live up to her name in every way. Her name "Asher Ariella" means blessed lioness of God.

When Asher was three months, we were having a terrible time with her eating. I was distraught. I asked the Lord for help, and God reminded me that someone had said the words "failure to thrive" over her. These words had brought a curse. When I renounced that and started speaking life over her, she started eating and now eats as much as any kid her age.

Start filling your baby's book (most important baby book you will ever fill out). Speak those words of life into them and watch them flourish.

Is there someone in your life who is not thriving, behaves cruelly or has behavioral or emotional issues? They need words of life as well!

Questions: Do you recognize words from those closest to you that acted as a curse in your own life?

Application: Jesus loves restoration. He loves beauty for ashes. He wants to reveal to us our purpose and identity.
- **Prophesy** —Speak life over your kids. During your quiet time, ask the Lord for His heart about your kids and speak it over them. Often it starts with one simple word. Speak that word out loud. You will be amazed at the changes that take place.
- **Freedom**—It's okay if you haven't understood the power of the tongue until now. Many people speak curses over themselves and others without even knowing it. The Lord wants you free from all curses—generational and word curses. Christ, Himself, became a curse and died so that we might

live in His fullness. "Christ redeemed us from the curse of the Law, having become a curse for us—for it is written, 'CURSED IS EVERYONE WHO HANGS ON A TREE' " (Galatians 3:13). You do not have to live like this. There is freedom in Christ! Here are a few steps to walk free from a curse.

o **Recognize**—The words that were spoken over your life and stop speaking anything that does not bring new life into existence. (Examples: "You're driving me crazy"; "it just killed me"; or "scared to death").

o **Renounce and repent**—Ask the Lord to cover with His blood any words that were not from Him.

o **Find scriptures**—Look up scriptures on the power of the blood of Christ.

o **Walk free**—Those words do not apply to you anymore. Believe in the Word. Believe His blood speaks a better word (John 15:3).

Prayer: Lord, I realize that every word is a seed, and I'm always sowing into people's lives. Help me to recognize where I fall short and to seek after Your thoughts concerning my children and the people I love. Lord, I plead the blood over any ill words spoken over my children or me. Lord, please reveal Your thoughts toward me. Pull down the strongholds of wrong beliefs I have allowed from what other people have said about me. Give me an identity rooted firmly in You.

Day 7

Focus Scripture: "There is an appointed time for everything. And there is a time for every event under heaven —A time to give birth and a time to die; a time to plant and a time to uproot what is planted." Ecclesiastes 3:1–2

Scripture Reading: Ecclesiastes 3

Mama said there'd be days like this

This is probably one of the more subjective devotionals, but because I have talked to many moms and quite a few felt this way, bear with me.

It's easy to feel lost when you first become a mom. Your identity has shifted, and you're no longer the person you thought you were. No one seems to understand that your body, which housed life for nine months, is now just a sagging, leaking cage of emptiness. For some moms, this feeling of desolation sets in as wave upon wave of hormones crash against their ever–fragile structure. Life now revolves around a sacrificial love to a blob that barely acknowledges your existence.

First-time moms often feel like they have lost a part of themselves. And in truth, a part of you has died—the old selfish you. As you get acquainted with this new you, go easy on yourself. You will learn to love this person.

Often a new baby slows life down (not as much with more than one kid but definitely with the first). Choose to use this time to lean into the Lord. Build your spirit up with worship music. Often, I found I could listen to things better than read so I would either listen to scriptures or sermons throughout the day.

Oh Momma, these days can be tough, but know better days are to come. Sure, it seems that no one could ever possibly understand everything that is going on, but God does. Do not succumb to bitterness and feeling like a victim. God is

watching you with His loving eyes ready to give you grace and strength for each new day (Lamentations 3:22–23).

If you let Him, this period of your life will not only be something you look back on fondly, but as concrete time with God that you will hold onto during the rest of your parenthood existence. Everything changes, nothing stays the same—embrace it. If you are not fond of your new life, don't worry—it won't stay that way forever. Learn to be content in the moment (Philippians 4:12).

Questions: What does success in this season look like to you?

Application: Write down the desires of your heart, including the ones that seem impossible. Put them aside and focus on throwing yourself wholeheartedly into this season. At a later date, look back on those desires and see which ones have changed and which ones are still constant. God puts desires in your heart for a reason. You might not understand how that desire will be fulfilled now but trust God.

Prayer: Lord, I'm so grateful that everything lasts for a season. Thank You so much for this season. Thank You that You produce beauty in every part of my life. Teach me to walk in the fullness of what You have for me. Lord, I want everything I can have out of this. Thank You that You anoint my head with oil; my cup runs over. Goodness and mercy shall follow me all the days of my life (Psalm 23:5–6).

Day 8

Focus Scripture: "But God, being rich in mercy, because of His great love with which He loved us, even when we were dead in our transgressions, made us alive together with Christ (by grace you have been saved), and raised up with Him and seated us with Him in this heavenly place in Christ Jesus."
Ephesians 2:4-6

Scripture Reading: Ephesians 2

So Die Already

Many years ago, I walked into a friend's house, and they were watching a sermon on TV. On the screen was this woman lying prostrate on the floor. Her face was smushed into the ground. She kept saying, "Jesus, don't leave me like this."

I thought it was super strange at the time, but it stuck with me through the years. I had never seen such vulnerability and openness coming from someone in the pulpit.

I've always had spiritual "FOMO" (fear of missing out). As long as I can remember, I've always wanted to see God move like He does in the Bible. I was created with a yearning that cannot be quenched, and it has led me down a path to figure out what really works when it comes to the Bible. I want to see people raised from the dead and brain cancer disintegrate. Don't you?

One of the hardest things for me to understand was what Christ did on the cross. I had no concept of grace before He gave me a revelation. My thoughts were, "Hopefully, eventually, I can kill off my old man enough that God would be happy with me." But that kind of thinking just leads to a lifetime of frustration.

The truth is, if you are saved, God sees you as a new creation. He has given you provision to walk it out. If you are still acting like the old, it's because you are resurrecting something that is already dead. Let it die. When it says His mercy is new every morning (Lamentations 3:22–23), so is His allotment of new life for the day.

If you confessed that Jesus is Lord and was raised from the dead, the old you died, too, on that cross (Romans 6:8). When Paul said, "I die daily" (1 Corinthians 15:31), He wasn't referring to his ability to crucify his own flesh but rather his acceptance of the work that was already done.

When we became saved, our sin was canceled, and we were transformed into a new creation. Now we actively have to choose to walk it out and put on the new man. We get to choose whether we pick up the characteristics of a dead person or Heaven.

We need a revelation of who Christ really is so we can walk in our new nature. Paul said, "For I determined to know nothing among you except Jesus Christ and Him crucified" (1 Corinthians 2:2). Jesus didn't die to leave you in the old man. He doesn't want you to live under the weight of the world, sick, emotionally spent and hurt. The secret is, let the old die and stay dead. God has so much new waiting for you on the other side.

Question: Are you struggling with "old nature" characteristics (anger, depression, anxiety, selfishness—to name a few)? "Now the works of the flesh are evident: sexual immorality, impurity, sensuality, idolatry, sorcery, enmity, strife, jealousy, fits of anger, rivalries, dissensions, divisions, envy, drunkenness, orgies, and things like these. I warn you, as I warned you before, that those who do such things will not inherit the kingdom of God" (Galatians 5:19–21).

Application: Every day, it is important to renew your mind. It's truly a great exchange. You give up the old for the new. You are replacing anger rather than conquering it. God will reveal what marvelous gift He exchanged for the old nature if you just ask and dig into the Word. A renewed

mind doesn't let the dead creep in. When you spend time in the Word, you understand how Christ sees you.

Many people think of God as the angry God of the Old Testament, but when Christ shed His blood on the cross, God only saw us with His perfect Son's blood covering us. He isn't mainly mad or sad, because then Christ's sacrifice would have been of no use. Read the Word; let it transform you into Christ's image. You were never made for yourself. You were made to be the image bearer of the Most High.

Prayer: Dear Heavenly Father, today, I want to let the dead be dead. I am taking a leap of faith and believing there is a new life on the other side of this that doesn't include my former behaviors. I believe that all that I am was put in Christ and the old was crucified. I will not resurrect the dead in myself. Things that I have marked off as being personality traits, I'm willing to let You have. I don't want to live in anger, bitterness, lack of peace and joy (insert whatever the Lord reveals to you in this area). God, please give me a revelation of Your goodness today—a deeper revelation of my identity. I don't have to live like this and I am actively choosing not to.

Day 9

Focus Scripture: "For everyone who asks, receives; and he who seeks, finds; and to him who knocks, it will be opened. Now suppose one of you fathers is asked by his son for a fish; he will not give him a snake instead of a fish, will he? Or if he is asked for an egg, he will not give him a scorpion, will he? If you then, being evil, know how to give good gifts to your children, how much more will your heavenly Father give the Holy Spirit to those who ask Him?"
 Luke 11:10–13

Good Gifts

When young, I had this irrational fear that God was going to make me marry someone whom I didn't find attractive. I felt like I was going to end up a martyr in my own marriage. Though wanting to give every aspect of my life to God, I didn't trust His decision making in this area. One day, I was introduced to a guy who was handsome, sweet and loved the Lord. Now, I didn't end up marrying that guy, but God spoke to me and said, **"I will never put you with someone you do not find attractive. I only give good gifts."**

Fast forward to my amazing husband. I often find myself taking pictures of him in everyday life because I want to remember every moment. He has so many amazing qualities, and he isn't hard on the eyes. What woman doesn't think her husband is beyond sexy when he loves her unconditionally! What woman doesn't want a man who cleans dishes and loves her children? My husband is by no means perfect, but God's gifts are. He gave me exactly what I needed.

Sometimes, it feels like a risk to trust the Lord, but those who trust Him are never put to shame. He will never let you down. There are three parts to the statement that *"God is never going to let you down"* that makes it work.

- **God comes down.** Guess what—He has already done this. He has come down and is waiting for you to do the other two parts. If it's in His word, it's true. He is not a man that He can lie. He performs His Word.

Believe that He walked the earth and lay claim to your victory.

- **You decide you aren't going to be let down.** Okay, you want something (it lines up with scripture) —He says He will do it. Don't be let down. Believe until you get it. Believe in His goodness and wait (Luke 18:1–8).
- **Realize what level you are meeting God at.** People, we are never let down by God. We get exactly what we expect. Most of us just don't expect much. We think we do, but be honest with yourself. If the Word says it, you can believe for it.

God is the Master gift giver. His gifts are always on time, personalized, and perfect for the occasion. On my birthday each year, I ask the Lord what He has for me. For as long as I have been doing this, I have had amazing encounters with Him close to my birthday as a result. He LOVES giving gifts.

Often, we withhold parts of ourselves, believing God's goodness won't be enough. It's completely irrational because the depths of God's goodness have never been exhausted. He is not capricious. He is not a God of whim. If you put your life in His hands, you will always come out a victor. If you do not, the world will always beat you down. Control is an illusion. You cannot prevent anything from happening. Give Him your life. Open your hands and your heart to Him.

Question: Have you been withholding parts of yourself from God? Do you believe He is who He says He is? Do you believe God is good?

Application: Ask the Lord where you are withholding your trust. Repent and dedicate that area back to God. Ask Him to reveal His goodness. Meditate on the scriptures

surrounding God's goodness (Psalm 119:68; Psalm 107:1; Psalm 31:19; 1 Timothy 4:4; James 1:17; Romans 8:28 — and many more).

Prayer: Lord, I know that all good gifts come from above. I'm placing my trust in You that You have plans to prosper me and not to harm me. I believe that no evil will befall me, and no plague shall come near my dwelling (Psalm 91:10). Lord, Your Word says that You work all things out for my good. God, I believe that those situations that look doubtful in my life are opportunities for You to demonstrate Your goodness. God, I give over my life and I believe Your Word. Thank You!

Day 10

Focus Scripture: "Truly I say to you, whoever says to this mountain, 'Be taken up and cast into the sea,' and does not doubt in his heart, but believes that what he says is going to happen, it will be granted him." Mark 11:23

Scripture Reading: Mark 11

Faith is Now

I once read a quote saying, "The least you are willing to accept is the most you will ever have"—unknown author. I often think about this. I question myself frequently, "Am I accepting below my potential?"

I have been stirred into the deeper things of life. I want to see the Word of God work. I need it to work. The world without God is a scary place for children. I need the Word of God to be true. And it is true … I can tell you story after story of God's magnificence—like how one of my kids fell off the back ledge of a couch onto a hardwood floor in slow motion (because I believe an angel caught him) and didn't even have a bump on his head. So many times, I have prayed for my kids, and God instantly healed them.

God is amazing—I tell you! I want to give you some thought provoking thoughts on faith. Take them with you into your prayer time and ask God for more revelation.

- **Faith is the assurance.** It's something you believe—you know that you know. You have set your heart to believe this truth. God speaks, and if you allow Him, He will train you to be aware of His voice.
- **Faith is now.** We go from faith to faith. The faith you had to believe for something last week is not the faith you will use on your problem today. Once you have received what you need, you no longer need that faith. You will need fresh faith for the next promise. An example is David. He killed the lion and the bear before Goliath. He didn't just walk

up to Goliath. He took on smaller battles first. The Lord is constantly leading us to trust Him in every battle. Be aware and conquer!

- **Faith is the title deed.** When you read something in the Word or the Lord speaks to your heart, you can rest assured that He will perform His Word. There is a lot of misunderstanding when it comes to "faith." Your faith is the title deed. But just holding on to the deed does not mean that you have taken possession of the promise. Most people wrongfully identify trust as faith. Faith is active. God gives it to you. Your faith grabs hold and then you start the process of taking your promise from the heavenlies into the natural.
- **Faith is the substance of things unseen**. Faith is not needed for the things you already have. Faith comes from hearing, and hearing from the Word of God (Hebrews 11:1; Romans 10:17).

Question: What needs do you have in your life right now?

Application: Write down a list of needs and then start researching what the Bible says about them. (There are many references to finances, health, and relationship problems.) If the Word of God says it (especially three or more times), it applies to you. Grab hold of a promise and start talking to God about it.

Prayer: Dear Heavenly Father, today, I ask that You help me build my faith. Speak to me about the possibilities of my life. Sow seeds of Your vision into my heart. I want to know what you think. I want to know Your heart. Show me, Father, how to build my faith. I want more of the miraculous in my life. I want to see Your Word work. Show me, Lord, how to grab hold and not let go. God, Your Word says I am anointed to preach, teach, heal, and help

people walk free. Show me Your strategy, Father! Thank You for always leading me into triumph.

Day 11

Focus Scripture: "Take heed that ye despise not one of these little ones; for I say unto you, that in heaven their angels do always behold the face of my Father which is in heaven." Matthew 18:10

Scripture Reading: Matthew 18

Angelic Help

Sometimes, we feel unnoticed. We do a crazy amount of work with nothing to show for it: cleaning up behind a toddler who just trashes everything. We do squats until we are blue in the face, but everything is still jiggly. We often feel overlooked and disregarded, but God sees everything.

I ran across this scripture (see focus scripture), and it's an awesome verse to just sit and meditate on. It is referring to little children (but also children of the faith). I love that we not only have an audience with the King, but also we have angels assigned to us, and they do as well. Nothing goes unnoticed. Every push of our heart is recorded. The second we pray, God releases the answer. It is up to our faith to bring it down from the heavenly realm to this one.

"Then he (this is an angel) said to me, "Do not be afraid, Daniel, for from the first day that you set your heart on understanding *this* and on humbling yourself before your God, your words were heard, and I have come in response to your words" (Daniel 10:12).

God sent an angel to Daniel in response to his words. The Bible says we will judge angels (1 Corinthians 6:3). Let me make this clear, I am not saying to pray to angels. We pray to the Father, and He sends angels to help. I don't want you making a doctrine about something that isn't true. Angels perform God's Word—not ours.

They will help us perform what God has asked us to do. He has already sent us the Holy Spirit, but He also has a heavenly host at His disposal. All we have to do is ask.

My mom has some property and cows. These cows tend to think the grass is greener in the neighbor's pasture and often jump the fence. My mom always prays, "Lord, send the hosts to help get the cows in," and it always works. It is like some unseen force directs them back into their pasture.

Do not underestimate how much God loves you and all the good things He has in store for you!

If today you don't feel like your actions are changing anything, please don't lose heart. Dig deep, seek understanding and humble yourself. You will see a harvest. Everything starts out like a seed to be watered and tended, but the fruit is completely worth it. Your jiggly butt will come into alignment. Your lost relative will know Christ through your love. Your family and friends will be transformed through your faithfulness.

Question: What do you know about angels? Are you living your life like you have been assigned one?

Application: Ask the Lord what He has for you. If what you have been called to seems too hard, ask Him to send you help. Remember, you might entertain angels unaware, so always be kind.

Prayer: Lord, I ask You to show me Your hand at work. God, most of the time, I do not even know what help I need, but You do. Please Lord, give me the help I need today. God, I want to live for You and be Your representation on this earth. Help me to demonstrate Your love in those around me. Teach me Your ways! I love You!

Day 12

Focus Scripture: "When you were dead in your transgressions and the uncircumcision of your flesh, He made you alive together with Him, having forgiven us all our transgressions, having canceled out the certificate of debt consisting of decrees against us, which was hostile to us; and He has taken it out of the way, having nailed it to the cross."
Colossians 2:13–15

Scripture Reading: Colossians 2

Identity

Too often we say things like, "I'll be happy when ____" [fill in the blank], but you won't. Why would I ever determine that my happiness was contingent on anything so fleeting?

I've never been one to lose my identity in people until my kids came along. God showed me that I had allowed my identity to be wrapped up in my children. Sure my life revolves around them. It's my job as a parent to feed, clothe, and emotionally support my kids. Let me show you the danger of my taking my identity from my small toddlers though. As my insecurities grow, I will stifle them from becoming their own people with their own identities. I will begin to live out my ambition through them and expect them to see the world as I do. In return, they will also learn fear, insecurity, and helplessness.

We can lose our identity in many things—people, jobs, hobbies, self–betterment . . . The Lord wants to show us who we really are—His creation, one so valued, worthy of redemption and freedom. When we accept this free gift, we are no longer sinners but righteous co–heirs because Christ lives within us. Freedom is Now! Faith is Now! Healing is Now!

You no longer have to live like once this or that happens you'll be a happy person. The Most High Living God made sure of that. So renew your mind (get in His Word) and be transformed with the knowledge of how amazing you are. I know moms are terribly busy, but they can meditate (mull over) on a scripture every day.

"It is the glory of God to conceal a matter, but the glory of kings is to search out a matter" (Proverbs 25:2).

Our identity is NOT found in the striving or even the end goal but in the One who created us.

Question: Where are you drawing your identity?

Application: Read these scriptures to see what God says about who you are then respond to Him. Listen; write it down—He loves you! These are just a few: John 1:12, 1 Corinthians 6:17, Genesis 1:27, 1 Peter 2:9, Galatians 3:27–28, John 15:15, Ephesians 2:10, Jeremiah 31:3, Deuteronomy 31:8, Psalm 139:14, 2 Corinthians 3:12, Psalm 30:2, and Jeremiah 29:11.

Prayer: Lord, we ask for a clear revelation of our identity in You. God, we need to know who You think we are. Lord, help these words get into my spirit. I want to know who I am in You. I want to know You and be known by You. This is the firm foundation I have been seeking! Teach me that I am the righteousness of God in Christ (Second Corinthians 5:21). I'm standing on the Word that I am the head and not the tail (Deuteronomy 28:13). The Bible says I shall decree a thing, and it shall be established in my life (Job 22:28).

Day 13

Focus Scripture: "If anyone fiercely assails you it will not be from Me. Whoever assails you will fall because of you. Behold, I Myself have created the smith who blows the fire of coals and brings out a weapon for its work; and I have created the destroyer to ruin. No weapon that is formed against you will prosper; and every tongue that accuses you in judgment you will condemn. This is the heritage of the servants of the LORD, and their vindication is from Me, declares the LORD." Isaiah 54:15–17

Scripture Reading: Isaiah 54

Warrior Training

There is fierceness to exercise—in attacking our weaknesses and disciplining ourselves for betterment. No one can make the decision to pursue health except you. It's a conscious decision to choose a better way.

Over two thousand years ago, Jesus paid the ultimate price so we could have everything we need for walking through life in godliness. He said, "Only believe." God completed His work on the cross. If we are suffering lack in health, prosperity, or any of the "promises," it shows a lack of understanding and belief on our part. He isn't going to die again, so we have to stand up and believe for what is rightfully ours.

"If anyone fiercely assails you it will not be from Me. Whoever assails you will fall because of you" (Isaiah 54:15).

I love this scripture. It reminds me of our workouts. God is creating us to be a weapon. It's a weapon of love that defeats all the enemies' advances. We are responsible in this process of our sculpting—physically, mentally and spiritually. "Whoever assaults you will fall because of YOU." We have to get God's heart on this.

A few years ago, the Lord gave me an open vision of His bride (I was awake, but could see it in my mind's eye). She wasn't an ethereal beauty in a white dress with a flawless complexion. She was a warrior princess with battle scars and a fierceness that softened when with the bridegroom. I saw Jesus come up to her and gently caress her scars with

admiration as she gently grabbed His hand and traced his nail holes. It was one of the most beautiful visions I have ever received.

Jesus is King and He is in love with us. You are His warrior Princess Bride.

Question: If you knew with absolute certainty that you were a warrior princess, how would you act differently?

Application: Today, spend some time gazing on His face and allowing Him to touch your scars. When He touches you, you can't help but know how beautiful you really are to Him.

Prayer: Dear Heavenly Father, please help me understand my identity. Jesus, let me see Your great love for me. I want to be your warrior bride. Teach me to fight so that I am not just throwing my fists into the air. I want to be effective. I want to understand Your strategy. God, open my eyes. Your Word says I tread upon serpents and scorpions and over all the power of the enemy, and nothing shall hurt me (Luke 10:19). I believe I do not have the spirit of fear but of power, love, and a sound mind (2 Timothy 1:7).

Day 14

Focus Scripture: But we all, with unveiled face, beholding as in a mirror the glory of the Lord, are being transformed into the same image from glory to glory, just as from the Lord, the Spirit. 2 Corinthians 3:18

Scripture Reading: 2 Corinthians 3

Becoming What You Behold

A negative plus a negative will never equal a positive. As women, we spend thousands of dollars on hair and makeup each year, but neglect the transforming power of the Gospel. We allow lies to drive us and pervert our ideas of beauty.

God's Word says, "You are what you behold."

God made us in His image (Genesis 1:26). This is what we lost at the garden (Romans 5:12). Christ came to restore God's image back to us (Ephesians 4:24). When we accept Jesus as our savior, we are transformed back into His image (2 Corinthians 5:17). This is why water baptism is so symbolic. You go in one way, die to the old, and come out washed clean and new.

I am planting seeds with my focus. I will yield a crop of good or bad fruit. Look at your consumer habits. When you listen to a song, I want you to look past the lyrics, the catchy tune and amazing voice rifts. Ask yourself if it lines up with who you truly want to be. Does it push you to be the strong, worthy of love, crazy—amazing woman you are? If it does, awesome; if not, why would you allow that in your spirit?

When I started paying attention to my music selections, I realized how negatively the world views women, including women musicians! Songs today glamorize abuse, neediness, sexual objectification, and even rape. One particular song laid out the message, "I'm going to let you use and abuse me, but my only desperate plea is that you

remember me." I do not want that song to define me. I am a stronger woman than that and so are you. I have value, and I will not let that kind of corrupted thinking into my life or home.

Whatever you tolerate will never change.

We deserve to be loved, respected and cherished by men and women alike. We can change the world just by changing our consumption habits. Our world is run on supply and demand. We have convinced ourselves that we cannot do anything to change, but that is not true. It starts with us. We are training the next generation.

Right now and for decades there's been an attack on peoples' value. God is love. When we look upon Him, we become what we behold. What if you taught children to be on fire for God? Kids so grounded in the Truth that they refused to listen or watch lies. Porn could be eradicated. Bullying could stop. Women wouldn't have to fight for their "rights" because they would be receiving the respect they deserve. Minorities would be valued and relationships would be healed. A true and transforming love would be the anthem that we'd sing.

All this could change —because of a higher standard in what we behold.

Question: What are you beholding? Does it line up with your created identity?

Application: I have a challenge for you. For even just one day, I'd like you to analyze yourself. Look at every song you listen to, every show (TV and movie) you watch and every article on Facebook you read.

Prayer: Lord, I want my eyes to be focused on You. Reveal to me Your true feelings about me so when I hear

the world's version, I recognize the lies. Lord, kindle my fascination. God, I want to see the impossible in my own life. I want to be consumed by my fascination of You. Show me Your character! Show me Your depths! As I gaze upon Your beauty, my life is transformed. Show me Your glory, Father! Blow my mind! Show me You are bigger than my imagination!

Day 15

Focus scripture: "Therefore, let us fear if, while a promise remains of entering His rest, any one of you may seem to have come short of it." Hebrews 4:1

Scripture Reading: Hebrews 4

Rest

I often see the meme floating around "You can't pour from an empty cup," and I would like to propose to you that you were never supposed to pour from your cup at all. You have access to a Kingdom with infinite resources and streams of living water. Tap in and pour from the fountain that flows eternal.

The Lord's rest is more complete and all around better than our rest. One of the things the Lord has been teaching me is that He can compensate me in rest. Being a mom, there are nights I do not get any sleep. I get out of bed the next morning, dreading the day, only to find God has already met me, and I am fully rested. The first time that happened, I kept waiting for the exhaustion to fall, but it never did because He told me He had it. I can be fully confident in His provision.

God created us to do impossible things. We can run and not grow weary (Isaiah 40:31). He has provided for us everything we need pertaining to this life and Godliness (2 Peter 1:3). As Christians, we do not have to bow to the laws of this world.

There are laws in the natural, but grace surpasses laws. We can expect the impossible. We can be rested even though we haven't slept, because the Bible says He gives us rest. So what is the big secret to this "rest"? It's surrendered trust. As I "rest" in God's goodness, He works with me to handle any problem. Aim to get sleep, but abide in His rest. One of the most vital scriptures we can understand is what God has for us in the way of rest. It comes from the Lord.

So many of us understand that even sleeping an entire night does not always cure our need for rest. When we run on our own fumes, our relationships, efforts, and children suffer.

Question: What have you been wasting your own strength on?

Application: So how do you enter into His rest?

- Recognize when rest is lacking from your life.
- Realize God has rest allocated to you. Rest is ceasing from work. It's surrendering trust to God. It is not automatic but a decision.
- Come to Jesus and unburden yourself (Matthew 11:28–30).
- Give up your right to understand His peace that passes all understanding and just let God lead (Philippians 4:6–7).
- Refuse to let the enemy take you out of that place. Moments will come when your eyes are diverted and your trust wavers, or it doesn't seem like it's working. Choose to submit again in obedience and cozy down into the rest.

Prayer: Dear Heavenly Father, thank You for Your rest. You are truly amazing. Thank You for Your provision. God, I ask You to help me unburden myself. I know Your yoke is easy and Your burden is light. Lord, help me to lay aside the things that do not match those descriptions. Lord, I want to get down in my spirit and have the peace that passes all understanding. I need this to be an effective wife, parent, and human being . . . Thank you, Lord, for your mercy!

Day 16

Focus Scripture: "That he would grant you, according to the riches of His glory, to be strengthened with power through His spirit in the inner man, so that Christ may dwell in your hearts through faith; and that you, being rooted and grounded in love, may be able to comprehend with all the saints what is the breadth and length and height and depth." Ephesians 3:16–19

Rejection

The Lord convicted my heart that I have been coming to Him with a bit of rejection. Several times in my life, I spent a period of time digging deep with the Lord, but because I didn't get as deep as I wanted, I felt rejected. Instead of continuing to dig deeper, I went at God from the side. Learning all about Him, reading my Bible, but not fighting to stay in the deep end.

Once He revealed that and I told Him I was ready to deal with my rejection, He extended an invitation. He literally woke me up and told me the next prayer I was to pray.

Rejection is a deadly force, a continuous self–fulfilling prophecy. You feel rejected so you draw back and reject, which causes more rejection. But that isn't who God is. He sees your rejection and holds His gaze. He sees your rejection and maintains His love. Lower your rejection walls and watch the floodgates of His love pour through.

I believe a lot of moms struggle with their bodies after the birth of a child, especially the more their body changes. The parallels of that struggle and your life with Christ can push one into new heights. If you allow Jesus to walk you through this season, your spirit and body will be transformed.

Health will radiate your being. Negative thoughts (like rejection) can stunt growth.

We have to stop thinking there is an end goal. Set goals, absolutely! But do you honestly think you will hit that

magical weight and be able to eat Twinkies and hamburgers with ease? Just like we can never explore fully the depths of God's love, we can always grow in our potential.

Do not be discouraged by where you are. You have to keep moving forward. We are all trying to get somewhere better, one tiny goal at a time. Accept yourself where you are right now!

Question: Are you acting out of rejection? Are you growing in maturity? Will you let Him touch these places in your heart?

Application: God created you to be a three-part person: flesh (body), soul (mind), and spirit. Your spirit communicates with God and governs the other two parts. Your spirit rests in your stomach area and sits on top of your emotions (The scripture talks about emotions being in your bowels and this is why people unknowingly say— "What she did was like a punch to the gut."

This is important because a lot of people try to communicate with God in their heads. Your mind doesn't understand the things of God—it's carnal by nature. Colossians 3:12; Philippians 2:1; Lamentations 2:11; 1 John 3:17; John 7:38; Psalms 22:14; Proverbs 18:8.

- Drop down into your spirit. Picture yourself seating yourself down into your spirit. God created us to be imaginative and visual people for this reason. We have to see it to do.
- Tell Christ you are releasing your right to keep these feelings. Then allow the emotions and pain welling up to be released by God through your spirit. I picture my hands pushing them away from

me as I release them out, but it is really just surrendering them for the Lord to work on.

- Don't stop until the emotions/pain/feelings are gone. This works for forgiveness and any negative emotion.

Prayer: Lord, thank You that You are doing a good work in me. Thank You that You are clearing out rejection, bitterness, depression, anxiety and whatever else might hinder love. Lord, give me strength to run. Help me to recognize Your voice and act accordingly.

Day 17

Focus Scripture: "Wives, be subject to your own husbands, as to the Lord. For the husband is the head of the wife, as Christ also is the head of the church, He Himself being the Savior of the body. But as the church is subject to Christ, so also the wives ought to be to their husbands in everything . . . Husbands, love your wives, just as Christ also loved the church and gave Himself up for her, so that He might sanctify her, having cleansed her by the washing of water with the Word." Ephesians 5:22–26

Scripture Reading: Ephesians 5

Gave Himself Up for Her

Sometimes God speaks so loudly, it seems like He is screaming.

But it isn't in rage. He can have rocks cry out if need be.

Sometimes God speaks to me while I am watching a television show, and it makes me absolutely awestruck. I was watching a TV show about a foreign queen who insisted that "to obey" be in her vows when she was married.

Later, her father took her husband aside and told him while His titles are important—his job is his wife. The ultimate act of patriotism is for him to come up underneath her and support her—to make her well-being his first priority.

Does this sound familiar?

"Wives, be subject to your own husbands, as to the Lord. For the husband is the head of the wife, as Christ also is the head of the church, He Himself being the Savior of the body. But as the church is subject to Christ, so also the wives ought to be to their husbands in everything . . . Husbands, love your wives, just as Christ also loved the church and gave Himself up for her, so that He might sanctify her, having cleansed her by the washing of water with the Word" (Ephesians 5:22–26).

Even if you aren't married, you can get a lot out of this. This scripture references how to have a great marriage on

earth and outlines the bond of your relationship with Christ. All relationships are perfected through Christ.

As the wife (Bride of Christ), make it a point to say "yes" to God and your husband. Do not take this as an excuse for staying in an abusive relationship. It isn't. It's his (His) job to come up under you and support you, but you have to do your part, regardless.

God expects us to walk out His Word whether anyone else follows or not. He honors our commitment and will work with us to cause circumstances that change the other person's heart if we are doing what we are supposed to be doing (1 Corinthians 7:14).

As an example, Galatians 5:22–23 speaks of the Fruit of the Spirit against which nothing can stand. This means that if you walk in the Fruit of the Spirit nothing can stand against you, and there will be change. God allocated you the grace to walk in the fruit. If your husband is angry or stressed and you walk in peace, there's a good chance he'll eventually change because he will want what you have.

God gives you a future and dreams. He will help you be molded into love. Say "yes" to Him and watch them unfold. Marriage is an equal part relationship. It works in harmony as you say "yes," and he comes up underneath and supports you.

I think all too often, people see marriage and kids as the burial site of their dreams. It isn't.

Are you wondering how they will manifest? You will have all the support of Heaven if you do your part.

Questions: Do you have the victory of Christ in your life? Does your marriage look like Christ and the Bride?

Application: Read Galatians 5:22–23 and Ephesians 5:22–26 until it becomes alive in your spirit. Make sure you are doing your part so God can do His.

Prayer: Lord, we come before You today and we reflect on Your beauty. Lord, transform me into Your image. God, I want Christ–like relationships. I want to be known for the Fruit of the Spirit! Lord, I believe You have allocated me everything I need to walk this out. Teach me how to demonstrate Your fruits. I want to manifest a sweet aroma as I walk in triumph.

Day 18

Focus Scripture: "For I determined not to know anything among you, save Jesus Christ, and him crucified." 1 Corinthians 2:2

Scripture Reading: 1 Corinthians 2

The Glory of the Gospel

How I love the Gospel! If it doesn't excite you, you probably haven't really heard the true Gospel.

Two thousand years ago, Jesus actively chose to come down as a man. He could have gone crazy and lived his life like the Amish Rumspringa, a period of time where the Amish parents allow their children to decide between the world and their religion. It can be characterized by wild and crazy behavior.

But instead, He chose to live intentionally sin free. His eye was on the prize of restoring God's image to mankind the entire time. Adam took on a different image when he ate the fruit of the wrong tree (See Genesis), but Jesus came to restore what was lost (Romans 8:29).

God, Jesus and the Holy Spirit each had their roles, and Jesus was going to make sure He completed His.

When Christ was crucified, all sin and sickness was tacked onto the cross. He paid the price for everyone. It is no mistake that His last words were "It is finished." After three days, the Holy Spirit went down into Hell and raised Jesus from the dead (Romans 8:11). The Holy Spirit is one powerful entity. Jesus went to heaven to be a mediator for us and sent us the Holy Spirit (1 Timothy 2:5).

We literally have the power that raised Christ from the dead living inside us if we want it! The Trinity (God, Jesus and the Holy Spirit) does not want us dealing with our sin nature. That is part of a dead man that no longer exists.

We are not supposed to resurrect the dead sin nature. When focusing on a negative, you will never get a positive. When we repent and claim Jesus as Lord, we are then in Christ, and our sins are gone. If we then fall short, we simply repent and are washed clean.

We no longer are sinners but the righteousness of God in Christ (2 Corinthians 5:21). We are supposed to press forward and allow the Holy Spirit to show us how to walk out this life and be more like Christ.

Sin had previously destroyed our world. The wages of sin is death. It was the cause behind all sickness and infirmity. But when Christ died, He redeemed us from the curse of the law. We get to walk in freedom—from sin, sickness, emotional pain, mental diseases, our past, and any other lies that have held us down.

Question: Do you believe that Jesus thinks you are amazing?

Application: Many of us walk weighed down by our old nature. Jesus came for a great exchange. We are not killing our flesh. That's already done if we choose to believe it. We're picking up the new man and walking it out. It is all a matter of focus.

Learn to practice the new man. When the old man starts acting up, learn to be aware and change your thinking (Philippians 4:8). We can have new thoughts. We can choose from a wide assortment of good emotions instead of anger, hatred, malice, sadness and bitterness. Be more intentional with your thought-life.

Prayer: Father, I lay down my old nature. It isn't mine. I gave it up when I chose to live in Your kingdom and be a dwelling place for You (Your temple). God, help me to

remember not to pick it up. Lord, I ask that You show me my new inheritance. Help me walk out my new man. I do not want to be known for anger, bitterness, sadness or wrath. I want to be known by my fruits. I am a new creation. I am aligning myself with Heaven. I am choosing the good. Thank You for Your sacrifice! I worship You, Father!

Day 19

Focus Scripture: "Behold, children are
a gift of the Lord. The fruit of the womb is a
reward. Like arrows in the hand of a warrior,
so are the children of one's youth.
How blessed is the man whose quiver is full
of them; they will not be ashamed when
they speak with their enemies in the gate."
Psalms 127:3–5

Scripture Reference: Psalm 127

Intentional

Second–guessing is one of my biggest problems as a mom. I find my first impression is often correct, but thank goodness for grace and mercy as I find my footing.

I struggled with potty training my firstborn. She was ready, then she wasn't. I backed down because I second–guessed myself instead of standing my ground. My logic concluded, "Even serial killers potty train their kids. This will happen eventually." My daughter was truly ready at the next attempt, but I still had to fight for it. My second child was a breeze afterwards. I had several chances to tackle this problem.

I think most of us struggle with thoughts of not being good enough. We strive for perfection and beat ourselves up when things don't go to plan.

God looks at our heart, not even our intentions. Where is your heart? Is it soft and pliable? Are you ready to take on the day, but be open to what the Lord is doing? He has little treasures throughout it for you to discover if you just live intentionally and check in.

We have to choose to intentionally live with an open heart. God wants us living in the aim. Think of shooting an arrow towards a target. Once the arrow is released, there isn't much you can do about where it hits. Your aim and technique will decide how well it lands. When God tells you something, consider it a target to reach during this journey. There will be many of these.

At times you'll miss it, especially when you first start out, but you typically can take more than one shot. God believes in training. He doesn't expect us to get it right the first shot. He isn't disappointed if we miss it, but He can help us improve and avoid misses when we're willing to let Him. David killed the lion and the bear before going up against Goliath.

When you start living like this, a quiet calm takes over, and you determine that it may be ugly, but you will get there. Perfectionism is judging by a standard that doesn't exist. The only opinion that matters is God's. Our identity in Him is so important.

Question: Are you living in the aim?

Application: Set your heart towards following God's heart. To live intentionally, means each day you wake up asking God what His plans are for you (Seek His Kingdom) and trying to execute them throughout the day as best you can. I like to think of it like a treasure hunt. God gives us the map and puts fun surprises along the way as we search out His heart. He really does leave surprises, whether it's a revelation from Him, a fun person that He wants you to meet, or a confirmation that you're doing what He called you to do.

Prayer: Lord, we want to live intentionally. Help us to not get caught up in perfectionism but to seek after Your heart. We want to know You in every possible way. Lord, thank You for the journey. Thank You for allowing us to grow every day. We set our heart on the things above. Thank You for always leading us.

Day 20

Focus Scripture: "I will not leave you as orphans; I will come to you. After a little while the world will no longer see Me, but you *will* see Me; because I live, you will live also. In that day you will know that I am in My Father, and you in Me, and I in you. He who has My commandments and keeps them is the one who loves Me; and he who loves Me will be loved by My Father, and I will love him and will disclose Myself to him."
John 14:18–21

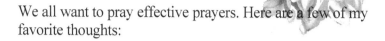

Prayer

We all want to pray effective prayers. Here are a few of my favorite thoughts:

- **God is a good Daddy (Matthew 23:9).** He wants to give you everything you need and the desires of your heart that He has put in you. So why aren't we seeing the manifestation? God is not a man that He can lie. He says He will provide. If our needs aren't being met, the disconnect, often, is on our end. We need a new revelation of God. While God sees mankind through the lens of the cross, He never sees your sin. He sees the work of the cross in your life. He sees you as beautiful and blameless. Ask the Lord for a deeper revelation of His goodness.

- **You do not have because you do not ask (James 4:2).** Sometimes we feel undeserving. We don't ask for more because we feel like we should be content (And we should, but this is Daddy. You would ask your Dad for things you wouldn't ask a complete stranger for.) When you are at your parents' house, you feel free to open the pantry and snack on anything there. Most of us do not get the massiveness of God—His unlimited resources and His unlimited ability. DO NOT LIMIT HIM!

- **Desire (Jeremiah 29:13)**—gets you into the heavenlies. God put a fierce desire in you to know Him and be known by Him. We often squelch it. WE DO NOT KNOW WHO WE ARE! Go boldly before the King and make your petitions known. He is the righteous judge. He rules in our favor. Let your desire be kindled. Let it out! It is like a great floodwater. The

ladder you climb to get to heaven. You are not an orphan. You have a right to be there. Stand on that right.

- **Decree and Declare (Romans 4:17)**—God has promised you so much: "Everything pertaining to this life and Godliness." Now it's time to open your creator (your mouth) and start creating. Spend time in the secret place. The Lord will tell you what He has in store for you. He will give you scriptures. Speak those scriptures out loud. Start declaring your promises. Every one of my children, God has told me about before conception. He wants to partner with you and tell you future things so you can speak the words prophetically into being.

Prayer is not saying eloquent words. It is a conversation. It is a relationship. It's knowing who you are and grabbing your favorite treat out of your Dad's pantry. It's confidence that you can ask for what you want/need and know you won't be turned down. It's boldness in the identity that you are His favorite (just as I am) and confidence (faith) in His Word that He is who He says He is.

Question: Do you believe if you ask God for something it will be granted to you?

Application: Build up your inner man and your most holy faith. We have access to the Kingdom. Our faith brings down the promise. The best way to build your faith is by reading the Word. Find scriptures that relate to your problem and meditate on them. Eventually, you will come to a crossroads where you decide that the scripture is black and white. Either I believe what the world says about my circumstances, or I believe what the scripture is saying. This is when you choose to have faith.

Prayer: Lord, we want to see Your kingdom come and Your will be done. Reveal to us the deeper things. Teach us how to

build our faith. Show us what You have for us. Holy Spirit, help us tear down the strongholds of unbelief so that we might gaze upon the beauty of the King. We want to see His glory in our lives.

Day 21

Focus Scripture: "But the Fruit of the Spirit is love, joy, peace, patience, kindness, goodness, faithfulness, gentleness and self–control. Against such things there is no law." Galatians 5:22–23

Scripture Reading: Galatians 5

Fruit Stand

I can remember back to when my son was only a few months old. He was truly a perfect child until around 8 o'clock at night. The sounds emitted out of that sweet mouth would make an interrogated terrorist give up his destructive plots. After many nights of holding a child who could not be comforted, around evening time, I started feeling like a caged animal.

I knew what my future held and it seemed bleak. Anger built up in me like I had never experienced. I never acted on it, but I was aware of its presence. I tend to be laid back about things like this, but I started experiencing rage. I wasn't thinking logically, or I would have begged God for an answer sooner.

When I asked Him what to do, He instantly showed me. He had already allocated me gentleness, patience, kindness and peace to deal with my situation. He told me to switch my older daughter and son's bedtime. I was putting him to bed after her so I could focus on breastfeeding him without her feeling neglected. As soon as I changed, the difference was night and day. He slept like an angel.

Growing up, I sang songs about the Fruit of the Spirit, but it wasn't until recently that I read the most important part of the verse, "Against such things there is no law." I always viewed the Fruit of the Spirit as something attained when you were really good with the Lord. It was a way of recognizing your devotion. If I could crucify my flesh enough, I would have the Fruit of the Spirit. Boy was I wrong.

After Christ died for us, He sent the Holy Spirit to help. If we ask, the Holy Spirit will live inside us. Every day, new mercies are given, and we are allotted a Fruit of the Spirit to handle all of our problems. Nothing can stand against the Fruit that God has apportioned, so choose to walk in it and see everything change.

Let me give you an example: A family member is bitter because someone died unexpectedly. They lash out at everyone in their path. You have an upcoming reunion with that person and are dreading seeing them. God allocates you His goodness and love. When you walk with what you are allotted, their bitterness is exposed in their own eyes because they see how cruel they are being to someone who sweetly loves them.

Yes, sometimes it takes a while, but I believe the Bible when it says, "Against such things there is no law." If you want to win the fight, you have to use the weapons God gives you. Nothing stands against the Fruit.

If the Holy Spirit lives inside you—you have the Fruit. What are you going to do with it?

Question: What Fruit is lacking in your life?

Application: We are not bad trees trying to produce good fruit. We have the Holy Spirit living inside us. The cross has transformed anyone who has chosen salvation. It's time to believe it, die to the old and become the person God created us to be—mighty warriors. Write down the negative emotions you have working in your life and in those closest to you right now. Ask God what His corresponding allocated Fruit is for your life. When each of the negative emotions show up, purpose in your heart to meet it head on with the corresponding Fruit.

Prayer: Today, Heavenly Father, I am going to use the gifts You allocated for me. I want to see the Bible work. I want to see lives changed and I am willing to be Your vessel to do it. Lord, help me recognize the Fruit that You have for each person I come across today. Help me to be faithful in the execution.

Day 22

Focus Scripture: "So if the Son makes you free, you will be free indeed." John 8:36

Free Indeed

When my daughter turned three, we put her in ballet class. To my horror, I quickly discovered she was "that" child. For some reason, I expected a teacher she didn't know would calm her wild and spontaneous nature. I was completely shocked at how little she minded, and it caused me to question my parenting.

One such day, she was particularly horrible to the point that the teacher had to give her a timeout. I got in the car and told her she had made me sad.

The next week after an okay–minding class, we got in the car. She said emphatically, "I make momma happy. I minded." My heart broke. I had missed it.

My daughter cannot take away from me, she can only add to me. Her negative behavior cannot touch me unless I let it. What a burden for someone to carry if they think they are responsible for our happiness!

When I am walking with the Lord, I do not need her to affirm me. I get that from Him. She's not free to be herself if she has to live to please me, and I'm not free to love her if it's performance based. We give our children their first impressions of God.

If as Christians our feelings are swayed by our children's actions, we are telling our kids that God's feelings toward us are contingent on actions. We are not "Sinners in the hands of an angry God" but children of God in the hands of His goodness.

God created my daughter. It's my job to gently guide her and polish the rough edges. When we were growing up, my mom always told me that God said to her, " If they (her children) do not obey you, they will never obey me." Strong words for a generation that likes to take the easy way out and not discipline their children.

I have to be careful that I do everything in love because I am encouraging my kids to grow into the people they were created to be. I do not want to stifle them, but I also need to do my duty to them as well. It is a fine line. The Gospel is all about letting people make the right choice in an atmosphere of love and acceptance.

The Old Testament used punishment and fear to motivate people to do the right thing. We never have to allow fear into our relationship. God has created a way to motivate people without imposing on their free will and it's called the Fruit of the Spirit.

There is a place in the Lord where we can live free from other people. When we are free, we can love lavishly, regardless of the situation.

Did you know you are God's favorite? He looked over the entire world and longed for you. He doesn't want less of you. He wants all of you. He wants to see you live up to your full potential. When you are confident of His love, you will be able to confidently give it.

Question: Are you living free from people?

Application: If you have controlled someone else's behavior or have felt controlled, it's time to come free.

- **First Repent to God and the person**—either way, you allowed something that was never yours to allow.

- **Ask the Lord for help**—He will start highlighting when this happens. It is then your job to recognize and stop. He will help you, but you are responsible to actively work on it.
- **Go free**—Once you have conquered this, later the devil likes to try to hit you with things that you have already conquered. Recognize the attack and say "no." Say it aloud. You are not your past. You died with Christ and all that is left is the new creation.

Prayer: Dear Heavenly Father, thank You for loving me first. God, I want to be free from me so I can love lavishly on those surrounding me. Show me the areas in my life where I have been manipulative. God, I repent for those times, and I ask You to help me walk free. I want to raise my children to be strong warriors in the Lord. Teach me! Thank you!

Day 23

Focus Scripture: "But about midnight Paul and Silas were praying and singing hymns of praise to God, and the prisoners were listening to them; and suddenly there came a great earthquake, so that the foundations of the prison house were shaken; and immediately all the doors were opened, and everyone's chains were unfastened." Acts 16:25–26

Scripture Reading: Acts 16

Holy Spirit, You Are Welcome Here

After two weeks of my kids waking up grumpy, I knew we needed a drastic change. My children have always been extremely sensitive to their surroundings. I learned really early on that the atmosphere I provided made all the difference.

After much prayer, I decided to set up an old phone as a music player in the hall between their rooms and play peaceful Christian music 24/7. The next morning, everyone came down the stairs cheerful.

Our atmosphere is extremely important. We, as Christians, get to control it. There are several ways to change your atmosphere: music, consecrating your house, and prayer.

As mothers, our responsibility is enormous. One of the biggest is what we let into our homes. We are the gatekeepers. Anything that affects our kids—both good and bad—comes through us.

In Acts, Paul has some amazing things happen including his shadow healing people. We can carry around a different atmosphere. I want to walk into a room and everything change because of Who comes with me. The Holy Spirit is not confined. When you invite Him into your life, He can bring an atmosphere of joy and peace to not only you, but also everyone around you.

I realize your church might not preach the full Gospel. They may try to tell you all that was for the apostles. Read

the Word yourself! Jesus is the same yesterday (two thousand years ago) as He is today.

If you only had one last chance on earth to speak and give a message that would pass down through the ages, what would that look like? Jesus's last words to the church were regarding the Holy Spirit. Jesus spoke about how He was sending the Holy Spirit to bring us power.

Receiving the Baptism of the Holy Spirit with the evidence of speaking in tongues is a subsequent event from salvation (Acts 8:5–12; Acts 8:14–17). You invited Jesus in at salvation for a new life; now you're inviting the Holy Spirit to come in to help you live it. Having the Holy Spirit inside me causes joy and peace to bubble up on the inside.

When I was five, I had just gotten saved. I was so excited about everything. My mom told me that the next step was baptism with water whenever I felt ready. I was on fire and wanted to immediately jump in as deep as I could go.

A few weeks later, I was attending a vacation bible school with a friend when they asked if anyone would like to get baptized in the Holy Spirit. I ran to the room after service. I was a bit disappointed when I realized there was no water involved, but agreed when I heard what it was all about.

From then on, I remember playing in my closet with my dolls, singing to Jesus. I knew I was talking to Him, but I was not speaking words that any human in my house could translate.

I can only tell you what was real in my life. I did not have a pastor telling me that parts of the Bible weren't true. I didn't know enough to know one way or the other, but it worked. Over the years, I have enjoyed my relationship with the Holy Spirit thoroughly.

Do you feel like parts of scripture aren't lining up with what you see in your life? It's never the Bible's fault. It's ours for not believing what it says.

Question: Do you have the Holy Spirit with the evidence of speaking in tongues?

Application: Read the scriptures. You will clearly see there are two different sets of scriptures regarding speaking in unknown tongues. One is your private prayer language and the other, which has to be translated, is for the unbeliever.

- Tongues for private prayer: Romans 8:26; 1 Corinthians 14:4–17; Ephesians 6:18; Jude 1:20–21; Ephesians 6:18; Acts 2:6–8; Mark 16:17–18; Acts 10:44–46; Matt 3:11; 2 Corinthians 3:6; John 2:37–39; Isaiah 28:11–12
- Tongues for the unbeliever: 1 Corinthians 14:5-14 and 22

Prayer: Holy Spirit, You are welcome in my life. I need You. I need the Great Comforter. I need the resurrection power. I need the joy that bubbles up eternal from You. Please make me Your dwelling place. Teach me the hidden things. Show me how to walk this life out. I worship You, Lord!

Day 24

Focus Scripture: "Consider it all joy, my brethren, when you encounter various trials, knowing that the testing of your faith produces endurance. And let endurance have its perfect result, so that you may be perfect and complete, lacking in nothing. But if any of you lacks wisdom, let him ask of God, who gives to all generously and without reproach, and it will be given to him." James 1:2–5

You Haven't Failed

Around the age of two, my daughter grew increasingly frustrated at her inability to communicate. While extremely smart, she was a bit behind in her speech. I had been praying about it, and the Lord started revealing a solution.

He reminded me of the godly men and women I admired. Many started out with learning difficulties, speech impediments, or other developmental problems. The Word of God transformed them.

Though very smart, my daughter's lack of communication skills trapped her in her own body. God showed me to speak the Word over her. When she was frustrated, I would speak over her, "I can do all things through Christ who strengthens me."

Not only did it build my spirit, but also it built hers. Before I knew it she was able to repeat scripture after me, and now she is talking up a storm. The Word of God releases those bound. The Bible says God will perform a work in those who believe (1 Thessalonians 2:13).

Often we take our children's well-being personally. We feel like we have failed if they are suffering in the slightest. The Lord has always been quick to point out to me that He is God. He can fix the broken. I have given my children to Him, and I expect Him to preserve my gift. We cannot value our children over the God who gave them to us.

I've always been nervous about babysitters in this day and age. One day God took me aside and gave me a stern

talking to. He told me, "How dare you. I can fix anything that happens to your children. Maybe I want these girls in your life for My personal reasons. Get My heart and get on board with what I'm doing. Are you going to stop Me?"

I've since straightened up. I cannot control everything, but I can trust God. I'm not big enough to get in a mess God can't fix.

Question: Have you given your children to God?

Application: God is a good God. When bad things happen, it is often because the devil wants to destroy the seed God has planted in our life, or our free will get in the way. If we aren't careful, it is easy to be led astray by the devil or our own selfish ambitions.

Today, meditate on God's goodness. Ask to see more. Surrender your kids to the only One who can keep them. If you are still unsure, here are a few of the many verses: Psalm 91; 2 Thessalonians 3:3; Deuteronomy 31:6; and Psalm 34:19.

Jesus already paid for everything. We have to agree with Heaven to see it.

Prayer: Jesus, wow, You are so good. Your Goodness pours out at every turn. Holy Spirit, please, reveal to us how to parent. Reveal a deeper understanding of the "Father's heart." Lord, we ask that You protect our children. Help us to get Kingdom perspective. There is nothing that can touch our kids that You cannot reverse. You are amazing! Oh Lord, we bless Your name. Thank You for Your faithfulness.

Day 25

Focus Scripture: "For all of you who were baptized into Christ have clothed yourselves with Christ." Galatians 3: 27

Scripture Reading: Galatians 3

I Put On Christ

The Kingdom of Heaven is a divine exchange, like being poor and wearing raggedy clothes until someone comes along, takes you shopping and buys you brand new everything—a complete wardrobe: shoes, undergarments, socks, outfits, dresses, pants, shirts and accessories.

You personally helped pick out everything. They are all in your style and fit perfectly. All of it was expensive and made of all the best material. You go home, overwhelmed at God's goodness but are quickly faced with a dilemma. You have to choose to put on the new and get rid of the old.

It isn't practical to keep your old ratty clothing around. They smell and could cause your new clothing to take on that odor. It sounds simple because your old clothes are really ratty, but they are familiar. You've spent so much of your life in them.

As you think about putting the new on, you might wonder if you are making the right choice. Meanwhile, the clothes sitting in your closet are stunning. Can you take a leap of faith that you will be happier in the new than the old?

How many of us would keep the ratty clothing? Instead of leaning on God's goodness, we live between two worlds. We live our dreary lives until we get into trouble and then we remember God's goodness.

Oh sweet one, you are living below your means. You were created for magnificence. God has clothed you in His beauty. When you prayed the prayer of salvation, God's

image was restored to you! He didn't die only so you could go to heaven but to bring heaven into you.

Christ died, and with Him, our old man died as well. When we choose Him as Lord and Savior then "It is no longer I that live but Christ that lives within me." We have to throw away the old and put on Christ. Our torn, ugly garments of anger and frustration are replaced with beautiful silk dresses of love and joy.

We get to exchange our mourning for gladness and our ashes for beauty.

Too often, Christians do not understand the divine exchange. They only see themselves as hopeless. YOU DO NOT HAVE TO LIVE LIKE THAT! It all starts with a choice—today, I'm choosing to put on Christ.

Question: Are you still wearing the old?

Application: The Bible acts as a mirror (James 1:23–24). The more you stare into it the more you become it. Read the Word, think the Word, and become the Word.

Prayer: Lord, today we boldly enter Your throne room. We put off the old and run after You wholeheartedly. God, You are so amazing. Thank You for our new wardrobe. Lord, thank You for clothing us in righteousness. Oh God, I just love the perks of this kingdom. Help me to understand my new life. Lord, I am magnificent because You are magnificent. I am blessed among men.

Day 26

Focus Reading: "But no one can tame the tongue; it is a restless evil and full of deadly poison. With it we bless our Lord and Father, and with it we curse men, who have been made in the likeness of God; from the same mouth come both blessing and cursing. My brethren, these things ought not to be this way. Does a fountain send out from the same opening both fresh and bitter water? Can a fig tree, my brethren, produce olives, or a vine produce figs? Nor can salt water produce fresh." James 3:8–12

Scripture Reading: James 3

Atmosphere

Words don't just matter—they change matter. A study was done where someone spoke positive over one group of plants and negative over another. Those receiving the positive words thrived while the ones in the negative group died.

I'd like to propose to you that we need a cleanse. A good cleanse of the negative words we speak. I believe our very atoms are changed by positive or negative words.

There is a system to this. Out of our hearts, we speak. So if our hearts are troubled with the negative, it comes out in our words. What we put in, we get out. We reap what we sow. If we put in positive influences (music, tv, friends, our own words, books), we will reap a good, positive harvest.

I want you to look over your life influences, like what TV series you like to watch. Are all the characters depressed? What about the book you were told was amazing but it is really a well–written downer? Or the music that puts down people to make a point? Ask yourself, are they really worth it? Do I give up my happiness and positivity for that?

God spent six days speaking the world into existence. It took thousands of years speaking through His prophets Jesus—our image restoration and release from bondage to sin.

Our Father works through words, but so does the devil. Words are the ultimate creator and destroyer in your life. Words have created the world we live in now.

The Lord convicted me that if I speak badly about a person, I would not be able to pray for them. I was canceling out the prayers with my gossip. "Does a fountain send out from the same opening both fresh and bitter water?"

God sees people for who they really are, and it isn't only my job to ask Him what He sees but to release it into their life as well. God spoke me into being. My mom didn't want kids for the longest time. God told her she would have a daughter named Abigail. He sent people into my life to encourage me to be who I am today. I want to do the same for others.

The Lord loves to teach us lessons. He uses the common everyday happenings to teach us. On one particular "teaching moment," I walked into the kitchen to my dog having spilled one of my kids' breakfast everywhere. I mean everywhere. I had been calm all morning through many crazy moments, but I lost it. I roared, "I hate you."

God spoke quietly to my heart. "You just cursed your dog. And maybe you feel okay with that, but I want you to understand everything you say has an effect."

I don't get to flippantly shoot the breeze. Samuel has always fascinated me because he was a prophet whose words never fell to the ground (1 Samuel 3:19). As it stands right now, I need many of my words to fall to the ground, as my words more often than not are lethal.

But here's the thing I can't pick and choose. I have to be a wise steward, so when I am commanding cancer to leave, it goes. God cannot honor all my words right now, but I am working diligently to change.

Question: Do you have mixture coming out of your mouth?

Application: Today, every time a person is ugly to you, ask the Lord what His heart is for that person. Start speaking out loud the good. One time, my husband was struggling with a co-worker. The only good thing I could think about at the time was that the man had nice eyes. So I told him to speak that out until the next good thing came around. It sounds silly, but it is a perspective change that will change everything.

Prayer: Lord, we ask for Your heart today. God, we want to see people as You see them. We love You and appreciate Your great love for everyone. I rest firmly in the fact that I am Your favorite one. Out of that confidence, I can give Your love away.

Day 28

Focus Reading: "Her children rise up and bless her; her husband also, and he praises her, saying: "Many daughters have done nobly, but you excel them all."
Proverbs 31:28

Scripture Reading: Proverbs 31

Supermom

The pressure to perform is astronomical; wife, mom, housekeeper, stay at home/workplace mom, cook, animal caretaker and poop aficionado. I would like to break down some cool thought about Proverbs 31 for you to meditate on.

- **The woman is responsible for everything.** If you read these passages of scripture, the man does not do much. He does not even have to make a name for himself. Do not be resentful of your position; with your huge responsibilities comes great reward. God will help you achieve your dreams if you submit them to Him. Accept your responsibility as from the Lord and ask Him how to accomplish it.

- **The woman needs a role in the finances.** I have met a lot of couples where the man sets the budget, and the woman lives with it. Every male I know wants a true Proverbs 31 wife, but he has to be the Proverbs 31 husband.

He needs to allow his wife to reach her full potential. He cannot be stingy with the finances. The wife knows the cost of living and how to get the best deals. Most often, she is in charge of buying the family's clothing, food, and other necessities. He needs to trust her, and she needs to learn to be trustworthy.

The first few years of marriage, my husband was not always happy about the way I handled our money, but I made it a point to allow the Lord into

our finances and never worry. If we needed something, I prayed (asked the Lord) then bought it.

God always sent the funds back into our bank account, and we never dipped into the red. It was definitely a time of growing both my husband's and my own faith, but God never failed us.

- **The woman needs diligence.** Now that we have children, we have less time to accomplish what we used to get done. We have to be more creative and diligent. We have so many amazing opportunities. Do not let them slip away! Children are a chance to restructure your life. You have an opportunity to realize what is truly important, carve out a time for it, and accomplish amazing things.
- **The woman is creating a legacy.** Our children are what we leave on this earth. Everything that we teach them will be passed down from generation to generation. This is both good and bad. Our kids will be empowered to follow their dreams if we teach them that they can.

I love to include my kids in my dreams because my kids do not keep me from them. They are a part of my dream. If you love to paint, have your kids paint with you. If you want to run a marathon, buy a jogging stroller. Teach them diligence and reward their hard work. They are our future.

Question: What really speaks to your heart in Proverbs 31?

Application: Line by line, ask the Lord for a status report on your life. He loves to walk you through your identity and show you how amazingly He has provided for you.

Prayer: Jesus, I want to be known for my diligence. I want my kids to be raised to know Your goodness. Lord, I need to hear from You. Who am I? What do You think about me? Thank You that I am defined by You. Thank You that You do not see me as I see myself. Help me to see myself the way You do.

Day 28

Focus Reading: "For the one who sows to his own flesh will from the flesh reap corruption, but the one who sows to the Spirit will from the Spirit reap eternal life. Let us not lose heart in doing good, for in due time we will reap if we do not grow weary." Galatians 6:8–9

Scripture Reading: Galatians 6

Law of Reproduction

If you are a mom, I really do not have to explain reproduction to you. When you were pregnant, you didn't for a moment wonder if your baby would come out a puppy. Humans have human children—this is the law of reproduction.

God enforces the law of seedtime and harvest (Genesis 8:22). Whatever we plant, we will harvest. How is your thought life? What seeds are you planting? As moms, we plant every day in new ground. Even when my children were too small to speak, I soon realized they understand more than they let on.

I am always amazed at what they comprehend. I cannot cuss around them and expect that seed to not come to fruit at a later date. Children are truly the ripest ground for seeds.

I once had a friend tell me, "My kids never stop talking. There are no secrets in this house. Every person we meet knows instantly what we believe and who we are as a family."

Trees are known for their fruit. You can tell everything you ever needed to know about a tree by the quality of its fruit. Have you checked your fruit? If you squeeze a lime, it would be crazy if you got a different juice out of it (apple, orange, grape).

So why is it that when Christians are pressed, everything but the Bible is likely to come out. We can reproduce

Christ in our lives. The Word is a seed. As we plant the Word, faith grows. If we tend to the seed, we will reap a harvest. It really is that simple.

It's important to read the Word. When you meditate upon the Bible, the Word becomes a part of you. You will harvest whatever you plant. As your kids get older and start testing boundaries, whatever you allow will be harvested later. If you sow fear, you will reap that harvest. If you plant love . . .

Questions: What seeds do you want to see planted in your children's lives?

Application: Write down a plan. Prioritize what is important to you. What really matters? As moms we get caught up in stinking thinking. We tend to be extremely hard on ourselves. We aren't meant to accomplish everything perfectly.

Figure out what matters and pursue that! Do not let condemnation over failure deter you from Christ's perfect work in you. He died to get sin off of your life, not because He views you as a lowly "sinner." Prioritize Jesus, and every aspect of your life will change for the better.

Prayer: Dear God, we align with Your Word. We thank You that because Christ died, we can manifest Jesus in every situation. Thank You that today when things get tough, You have already met me. Thank You for the provision of the Fruit of the Spirit. Thank You that my every problem has a solution already released. Lord, I rest in Your peace. I am content in Your love. Thank You for being a good Papa!

Day 29

Focus Reading: "This is the confidence which we have before Him, that, if we ask anything according to His will, He hears us. And if we know that He hears us in whatever we ask, we know that we have the requests which we have asked from Him."
1 John 5:14–15

Scripture Reading: 1 John 5

Wild Provision

I have lived a pretty wild life of seeing the depths of God's goodness. I've always had every need met. I was able to put myself through college (miraculously, because looking back I am still not sure how) without any debt. I never starved, and I always had a roof over my head.

I can remember believing God and going forward only to have money show up in my bank account or the answer to every problem met. It's a radical way to live, let me tell you. I always had enough money and at least two good bras. (Don't underestimate the importance of either.) God can make a dime stretch like you wouldn't believe.

But see, that's part of the problem . . . You have to believe. You have to desire. If all you believe for is enough food for three meals a day, then that's what you will get. But if you hunger and thirst for righteousness—oh wow, the possibilities are endless.

It's important we know who we are. When you put yourself under God's Kingdom, you have access to His resources. He will always meet your needs, but you will have to contend (go after) for the dreams He places in your heart.

This is pretty much a Kingdom principle, which is why it works for fitness as well. You need a body, but you desire a healthy one. You need food, but you desire tasty, healthy food.

Let's say that you believe it will take "X" to get you on your fitness goals. Take it before the Lord. He will show you how

to make it happen. Doors will open, finances will shift, gifts will come out of nowhere, but it all started because you believed you were part of something bigger than yourself. You chose to believe that you had access to a Kingdom of infinite resources. APPLY THIS TO EVERYTHING and see your life transform.

Question: What is your belief level at right now in the area of finance, health, fitness, and God's ability?

Application: Ask God to stretch your beliefs. Start by believing that your debt will be paid off. Make goals to accomplish this and watch God meet you. He will always meet you in your faithfulness. Do not forget to give because He so loved the world that He GAVE.

Being a cheerful giver is a sign of being like Him because you love Him. He loves to give good and perfect gifts because that's who He is. We get to be like Him. The added benefit is we reap what we sow. We should never give to get, but we do get when we give.

Prayer: Lord, I thank You for my finances. I thank You that You give us our daily bread, both spiritually and literally. If I trust You, I will not lack. I thank You for what You have provided for me. Lord, I want to honor You by being a good steward of my money. Teach me to walk in supernatural wisdom. I decree that there is a way out. As I walk this out trusting the Lord, God will meet me and help me.

Day 30

Focus Scripture: "But if the Spirit of Him who raised Jesus from the dead dwells in you, He who raised Christ Jesus from the dead will also give life to your mortal bodies through His Spirit who dwells in you." Romans 8:11

Scripture Reading: Romans 8

Healed

When I was two months old, I was diagnosed with Idiopathic Thrombocytopenic Purpura (ITP). The severity of it varies, but basically, your body doesn't make enough platelets. ITP means your body won't stop bleeding from even the tiniest cut.

I had bruises all over my body from my mom just changing my diaper. My mom was told that I was the youngest ITP patient that they had ever seen at the time.

I was her firstborn and my poor distraught mother hit the ground on her knees. She distinctly heard God say, **"She will be well."** My mom clung to that word for months through horrible doctor appointments and spinal taps with no anesthetic. God told her something, and she resolved she would believe.

When I was nine months old I was scheduled to have another spinal tap. As my mother was waiting for results, the doctor came in the room and asked her if she had given the sample of blood that morning. My platelet blood count was not only normal, but it was high.

God had healed me, and I've never had a problem since. With all the scrapes and bruises I've endured, it probably would have been a dangerous childhood for me.

Moms quickly realize that there aren't a whole lot of things that can be done for a newborn with a cold. We keep them home and protect them as best we can. Most medicine is

too harsh for them, and often, we are asked to just wait it out. Many parents do not even look at that as an option.

The Word of the Lord is clear— He loves to heal the sick. The best medicine we can give our children is the Word of the Lord built up in our spirit.

The Lord entrusts children to us. We are in charge of their well-being until they leave our household. Just like our spirits are in control of our own bodies, they are in control of our children's as well. We have the right to command healing into their body and see them restored.

This is why when praying for someone's child, biblically, it is best to get the parent's permission.

I've seen the Lord do some great healings in my family. Before I met my husband, he broke his back in high school, and the doctors said they were unsure if he would walk, and positive he would never carry more than ten pounds. A few years later my husband climbed a mountain in the Himalayas. He takes out the trash for me every day and that weighs way more than ten pounds.

My son was born with one of his ears flattened at the top, and as I prayed over it, it became normal.

My daughter refused to eat, and the Lord gave her an appetite.

I was cured of a thyroid problem that I would have had to take medicine for the rest of my life.

God is still a good God who heals!

Question: Do you believe Jesus heals the sick?

Application: Read the scriptures about healing. They are your arsenal in times of trouble. My first response when my kids seem to be coming down with something is to pray. I put on worship music, hold them and proclaim God's goodness. It is rare that my kids actually get sick.

Prayer: Thank You, Lord, for giving us Your Word! Thank You that Your Word is true! Your Word says the prayer of faith shall heal the sick. I am choosing to believe it! Lord, I need Your healing power. Thank You that You released Your resurrection power onto the earth and that Your Word comes alive in my life.

Day 31

Focus Scripture: "Be anxious for nothing, but in everything by prayer and supplication with thanksgiving let your requests be made known to God. And the peace of God, which surpasses all comprehension, will guard your hearts and your minds in Christ Jesus.

Finally, brethren, whatever is true, whatever is honorable, whatever is right, whatever is pure, whatever is lovely, whatever is of good repute, if there is any excellence and if anything worthy of praise, dwell on these things. The things you have learned and received and heard and seen in me, practice these things, and the God of peace will be with you." Philippians 4: 6–9

Scripture Reading: Philippians 4

Programming

Let's talk programming. We came into the world a fairly blank slate. Our mind is like a digital video recorder. It does not have inspired content. Without God, we do not have one unique thought that does not follow what we were programmed to think. Our minds have had input from our surroundings and runs off that program.

Think about it, in kindergarten, someone started adding reading to your programming. Depending on how you were raised, you might have been programmed to go to church. Anything that is normal to your family can be a program (traditions, ideas, sins). It gets passed down from generation to generation once introduced into a family. All the skill sets you have learned, everything you think, and everything you do—was a learned behavior. The world runs off these programs.

We are putting thoughts into our children every day. The word says, "Train up a child in the way he should go, even when he is old he will not depart from it" Proverbs 22:6. We have an awesome responsibility as parents. It's our programming (not the church, not our kids' friends, not our Christian schools or daycares) that will determine if our children stay the course.

Your mind is not the part of you that makes you special. It only demonstrates what was programmed into it. You do not have to follow your programming. You can change the DVD.

Here are some examples of what we are taught contrary to the Word of God:

- **We are told, "Don't get your hopes up."** The Word of God says Hope big! Hope is the anchor of the soul (Hebrews 6:19). It is the ledge that faith sits on (Hebrews 11:1).
- **We are told, "You made your bed, now lie in it." The** Word says "If I ascend to heaven, You are there; if I make my bed in Sheol, behold, You are there" (Psalm 139:8).
- **We are told, "What you see is what you get."** The Word says there is an unseen realm, and we do not have to live by only what we see (2 Corinthians 4:18).
- **We are told, "It's flu season."** The Word says He died for our healing (1 Peter 2:24). The power of life and death (and health) are in the tongue (Proverbs 18:21).

Your born-again spirit is where you can get inspired content. It's also a strong force that will reprogram your mind if allowed. You can renew your mind by putting the Word in and stopping partaking in negative programming.

You do not have to think the same thoughts over and over again. There are thousands to choose from. Pick another one! When something happens to us, we get to choose how to react. If we choose a Fruit of the Spirit, we invite Kingdom into our problem.

Every day, we run what we know. We can run programs of hate or do something totally out of the ordinary. We can change what we know and choose another program. The Bible says to build up your spirit. It has to be stronger than the flesh and body. We have to exercise it just like anything else. Worship, praying in our prayer language, reading the

Word, spending time with God and love—all build up our inner man and help change the program.

It was life changing to me when I started realizing that a lot of my reactions were programmed. I didn't have to respond that way, but I did have to take every thought captive.

Question: Do you spend time building up your spirit?

Application: Ask the Holy Spirit to highlight the negative programming. Often we don't even know something can be different until God reveals it's a problem.

Prayer: Lord, I thank You that when I agreed with Your plan for salvation, You placed inside me new programming. I thank You that you have already given me everything I need. I ask that You teach me to walk in the new. Reveal to me the old programming that I am allowing to permeate my life. I have a way better deal in You! Thank You for the good news! I do not have to live bound by sin—I am the righteousness of Christ.

Day 32

Focus Reading: "Learn to do good; Seek justice, Reprove the ruthless, Defend the orphan, Plead for the widow." Isaiah 1:17

Scripture Reading: Isaiah 1

Women, Mobilize!

I like to volunteer for a group that reaches out to sex trafficking victims. I have learned it's important to let my heart break for the things that make God's heart break.

I'm all for women's rights—all women. In America today, we have women who are slaves. They are being sold and traded for sex. The average age of entering into prostitution is 14. These women didn't choose this—it was chosen for them.

Check into the actual research. Many of these poor girls were lured out of terrible situations with the promise of love. Church, we aren't protecting our children! As an American, I would have never believed this level of hatred towards women existed until I saw it with my own eyes.

In my own country, women were considered no higher than cattle. I have always commanded respect everywhere I go, but on the streets (the area prostitutes walk to pick up clients), I was property. A man was considered worthy of respect whether he had his brains intact or not, but a woman was only valued for her body.

Hatred for women has consumed the church as well. Pornography ravages our church. Single moms are still considered unworthy. There are quite a few men who sit under a pastor on Sunday and go home to abuse their wife. God created women, and they add value to this world.

The church needs to acknowledge their worth.

Recently, women have started mobilizing protests. We can do more than that—we need to be observant. We need to be abolitionists. Motherhood is one of the most important jobs a woman can do, but we also have to leave a world our kids can live in. If everyone did a little, these would no longer be issues. As moms, we have our hands on our future. We can change things.

Question: Do you have a burning desire to see change in an area? God has placed a dream inside you. What moves your heart?

Application: Here are a few ways you can help:
- **Educate yourself**—Learn about what gross injustices are going on in your area. Check out sex trafficking ministries, pregnancy centers, your church and domestic violence help centers. Look up the statistics on porn and how it destroys the mind.
- **Pray**—Prayer changes things. Learn how to intercede on the behalf of victims.
- **Get involved**—There are so many ways to do this. You can volunteer your time, your funds, and any special skills you have to any of these causes.
- **Raise your kids**—Pornography degrades women. Teach your kids about porn. Monitor their devices. Love on your children and those around you. Provide a safe place for kids to come to your house and meet Jesus.
- **Observe**—The signs of abuse are out there. Offer love to those who are suffering. Give them a safe place.
- **Speak out**—I have run into many people who are oblivious to the truth. Speak the truth in love!

Prayer: Thank You, Lord, for allowing me to be born at such a time as this! Thank You that You in Your infinite wisdom created me a woman. I am so grateful. Lord, show

me ways that You want me to jump in and build others up. Lord, let me be used by You!

Day 33

Focus Scripture: "For though we walk in the flesh, we do not war according to the flesh, for the weapons of our warfare are not of the flesh, but divinely powerful for the destruction of fortresses (strongholds). We are destroying speculations and every lofty thing raised up against the knowledge of God, and we are taking every thought captive to the obedience of Christ."
2 Corinthians 10:3–5

Scripture Reading: 2 Corinthians 10

Deal with Strongholds

Often the biggest strongholds in our life reveal what we are called to do. What makes you afraid?

When I was a teenager, I had a dream about being thrown into a prison in a foreign country. This so shaped my views on this country that I never wanted to visit. As an adult, the Lord revealed how irrational that truly was. I learned that I have a heart for the people of this country and look forward to visiting them one day.

Honestly, so what if I get thrown in prison? My mission does not change. My mission is to "preach, saying, 'The kingdom of heaven is at hand.' Heal the sick, raise the dead, cleanse the lepers, cast out demons. Freely you received, freely give," (Matthew 10:7–8). I can do this here, there, anywhere.

The devil is strategic. If he can paralyze you with fear, you will never complete what you were called to do. His mission is to defame God's character. He wants you to be blind to God's goodness. Often we attribute every bad thing to God, "Why would God let this happen?" But the Bible says every good thing comes from above (James 1:17).

We live in a fallen world, but we do not play by its laws. When we get saved, we get transferred to the Kingdom of Light, but at that point, we have to pull down the strongholds and replace them with the attributes of God. It's no mistake that the scripture states "taking every thought captive," right after pulling down strongholds.

My definition of stronghold is anything that exalts itself against the knowledge of God. There comes a point in every Christian's walk where we are faced with choosing between what the Word of God actually says and what we have been taught in church or see in the natural.

Sometimes we have wrong doctrine, and we did not even know it. The Bible says we have a right to walk in divine health, but how many people do we know who are walking this out? The Bible says He has plans to prosper us, but how many Christians are in debt?

We are the ones not fulfilling our end of the bargain, not God. We have to pull down the strongholds in our mind. We have to stop believing things that are not true. WE ARE destroying speculations. It is our job.

I find that most Christians are sitting around waiting for God to do something He has already done. They are upset because God won't do something, when in reality it's already finished. They are the ones who won't move into the new.

We all want to be free. Choose today to walk out of your bondage and into freedom.

Question: Do you feel like a new creation? Are there things that you are waiting for God to do?

Application: Ask the Lord to reveal the strongholds in your life. He loves to answer this prayer and will! Do not be afraid if problems start popping up. This is how you work through a stronghold. Lean into the Lord and work it out with Him. Example: If your co-worker (friend) is really mean, maybe the Lord is trying to pull down a stronghold of rejection. Ask Him. He will tell you what He is doing.

Prayer: Lord, We are so grateful that You do not leave us in our current state. Thank You for placing everything we need to be successful in this life inside us. I love that You have big plans for me. Lord, help me to pull down the strongholds so I can dare to dream again. These strongholds have had me bound in hopelessness, but they are a lie! Shine Your light of truth on my life as I gaze at the Word! Thank You, Father!

Day 34

Focus Scripture: "For this reason also, since the day we heard of it, we have not ceased to pray for you and to ask that you may be filled with the knowledge of His will in all spiritual wisdom and understanding, so that you will walk in a manner worthy of the Lord, to please Him in all respects, bearing fruit in every good work and increasing in the knowledge of God; strengthened with all power, according to His glorious might, for the attaining of all steadfastness and patience; joyously giving thanks to the Father, who has qualified us to share in the inheritance of the saints in Light."
Colossians 1:9–12

Scripture Reading: Colossians 1

The Reality of Easy

We have all thought it—why can't this be easier? Why does this have to be the hardest thing I've ever done?

It might have even made you contemplate giving up. You look at other people's lives, and their success seems effortless. This is dangerous thinking because true success is never easy. I've heard many successful people describe their journey as an iceberg; all you can see is the top.

Reality shows are notorious for showing us the unrealistic side of "easy." There are many reports of people losing their homes after a reality TV show helped them, either because the house wasn't finished completely (shoddy workmanship and expensive upkeep), or they went into foreclosure because they didn't have the wealth to maintain it. You can fix someone's circumstances, but if they do not earn it, they have no idea how to maintain it.

This goes for the reality weight loss as well. When the trainer and personal chef leave, devastation often follows. It's been reported that many of the contestants gain back all the weight.

We cannot be satisfied with short–term success. There is no miracle pill that will save us from ourselves. We just need a dose of good ole fashioned discipline and endurance.

I recently made a statement to someone— "I won't put up with this false belief. I have started at the bottom before and would rather go back to nothing than be here." I know

how to bounce back from perceived failure. I've done it so many times that I know the depths of my capabilities.

I have probed these depths quite extensively and leaned so hard into God that I know the unlimited nature of His grace. Do not fear being brought down. Endurance and the ability to maintain are being built in you.

Rise up today! This is a new season for you! It won't be easy, but let's make it notable.

Question: Do you spend your life wishing someone could just do it for you?

Application: God is like a bulldozer. He will get you through the situation, but you have to decide to move. Do not spend another minute wishing someone could rescue you. You are an amazing creation! The living God inhabits you. Get up and start conquering!

Prayer: Thank You, Lord, that You meet me where I am. God, I need a breakthrough in my life. Thank You for going through this process with me. I am a victor! I have a testimony! I am not one to sit on the sidelines and wish this were easier. Your yoke is easy. You are doing all the heavy lifting. I am just trusting in Your goodness!

Day 35

Focus Scripture: "And He was saying, "The kingdom of God is like a man who casts seed upon the soil; and he goes to bed at night and gets up by day, and the seed sprouts and grows—how, he himself does not know. The soil produces crops by itself; first the blade, then the head, then the mature grain in the head. But when the crop permits, he immediately puts in the sickle, because the harvest has come." Mark 4:26–29

Scripture Reading: Mark 4

God's Orchard

Most often when you plant a fruit tree, the first year, there is no fruit. The second year, still no fruit. The third year, it starts bearing fruit but it isn't much and it doesn't always taste great. Fourth year is better and fifth year is full production.

This is how our lives work as well. Not exact timelines but the process is the same. We have our own personal timelines as to when we changed our thinking (planted a seed) and started in a new direction. I've heard that God demonstrates in the Bible that He doesn't see conception and birth as two different events.

When God plants the seed of conception, it is a done deal on His end. At that point, it becomes our mission to host the promise. We have to believe and water the seed. It's our job to tend to our soil and allow ourselves to be brought into the new covenant. We walk in faith to obtain our promises. We cannot base what we believe about the Bible on what we see.

This is why it's important to plant, because there is a long period between growth and harvest. Whatever is producing in your life right now started years ago. Some of this, such as eating healthy or even potty training was planted at an early age.

Pruning, watering, fertilizing, and sun all play their part. It's also important to plant in your kids' lives at a young age. Children are fresh from heaven. They do not carry around the baggage that we accumulate over our lifetime.

When my daughter prays for someone, she simply believes. She is not weighed down by false doctrine or past experience. She takes her measure of faith with the Word and sees people healed. God asks us to come to Him like children. It's really that simple.

Question: What season do you feel like you are in with the Lord?

Application: God is faithful, and we are supposed to be a faithful people. Do not give up just because you have not seen the manifestation of God's Word in your life. It is coming. From the moment you prayed, it was released.

Prayer: Dear God, thank You that my roots are going down deep. I am excited to see Your Word come to fruit in my life. Lord, I want to build up my promises. Please speak to me and tell me truths about my future. I want to have things to hold on to. Thank You, Lord, for Your faithfulness!

Day 36

Focus Scripture: "With the fruit of a man's mouth his stomach will be satisfied; He will be satisfied with the product of his lips. Death and life are in the power of the tongue, and those who love it will eat its fruit. He who finds a wife finds a good thing and obtains favor from the LORD." Proverbs 18:20–22

Scripture Reading: Proverbs 18

Enjoy

I'm your typical girl. The only difference between me and anyone else is I'm not afraid of what it will take to get what I want. Marriage is tough and rewarding. Kids are a rollercoaster. Life is not easy.

A while back, the Lord told me that He wanted me to stop working on my marriage. "Say what, God?" There are so many marriage books. I've heard so many older couples give the advice, "Never stop working on your marriage."

God said, "I want you to stop working on your marriage and start enjoying it."

On paper, God's Word to me sounded really awesome. I quickly realized good marriages do not have "state of the union addresses." They never talk about what could be better in their marriage. They just love each other for who they are. They banter, joke and enjoy each other.

By not working on my marriage, I am laying down the pieces that don't work. I do not get to pick them back up. I get to only choose to see the good. I make the choice that every moment is fun.

As part of this glorious marriage, I get to die. My old self dies and the new one takes over. I have the privilege of allowing my marriage to push me into being more like Christ.

So every day since then, I have tried to make an active choice not to "work on my marriage." I have even said, "I

can't say what I think right now or it would be working on my marriage. And I won't do it." I strive to make an active choice to "enjoy."

The ironic thing is I'm not sure anything has changed about my marriage but me. Because I've chosen to "enjoy," my quality of life has improved.

Is marriage hard sometimes? Yes! It matters to God that we walk out a life of triumph.

Choosing to enjoy lets me see my husband for who he really is. OHMYGOSH, he is amazing! God just looks at this perfect gift He gave me and is like, "Yep, you are welcome."

If you are struggling with someone, try enjoying him or her. You will release yourself and this person into their true identity because God enjoys us, regardless. He only sees us through the lens of the cross. He is not mad or sad but immensely happy with this amazing person He created.

I even heard God whisper, **"Enjoying works for your kids as well."** Their behavior will change when they feel enjoyed without consequence.

Question: Could you use some "enjoyment" in your life?

Application: Think about the relationships in your life that are tough. Ask the Lord for a revelation on how to enjoy them. Make a decision that you are choosing to impart joy into this relationship, whether you feel it or not.

Prayer: Thank You, Lord, for enjoying me. God, I ask to feel your pleasure for me. I thank You for your great love. Help me to pour out Your love onto others. No person is too-far-gone or unreachable. Your Love permeates

everything. I want to walk into a room and everyone to know that Jesus lives inside me and His love is poured out.

Day 37

Focus Scripture: "And He has said to me, 'My grace is sufficient for you, for power is perfected in weakness.' Most gladly, therefore, I will rather boast about my weaknesses, so that the power of Christ may dwell in me. Therefore, I am well content with weaknesses, with insults, with distresses, with persecutions, with difficulties, for Christ's sake; for when I am weak, then I am strong." 2 Corinthians 12:9–

Scripture Reference: 2 Corinthians 12

Floating in Grace

As a mom, it is easy to get caught up in hormones. Everything can seem so intense and rich; terrifying and daunting. I used to be easily swayed. I often would count a day as being bad by one experience instead of weighing my entire day.

I had a tough time seeing the positive because the negative weighed so heavily on me. I love that today's scripture is in reference to Paul's "thorn in the flesh." How often do we feel that our burden is just too much to bear? He was given this burden and told that he could handle it because of Christ.

Now, I've stopped viewing days as good or bad. I've started seeing them as full of grace. Sometimes, I'm overwhelmed at how amazing the grace is and sometimes the grace is keeping me afloat. Either way, I'm living empowered by grace.

Let me give you an example—most people would view this day overall in the bad category but that would be wrong if you look at the entire list. This was an actual day:

- Wake up to dog throw-up and a kid crying. (Check Negative Box)

- Potty training my youngest and he is doing well. (Check Positive Box)

- Homemade cinnamon rolls for breakfast—insanely good. (Check Positive Box)

- Son accidentally pooped his pants. (Check Negative Box)

- Daughter has an accident in hers. (Check Negative Box)

- This year's "Poopapocalypse" preliminarily declared as the dog literally poops half his body weight on the rug. I wish I was exaggerating. (Check Negative Box)

- Workout hasn't happened yet. (Check Negative Box)

- Husband brings pizza home for lunch. (Check Postive Box)

- At kids urgent care getting my daughter checked out. (Check Negative Box)

- Husband cleaned house. (Check Positive Box)

- Kids sitting together laughing and enjoying a quick meal before an extremely late bedtime. (Check Positive Box)

All moms want to enjoy every second of their children's lives. I encourage you to change your thinking. There are only two types of days—flowing in abundant grace and days that require even more grace.

Question: Do you believe in grace?

Application: Look up the meaning of grace, pray for understanding, and read the scriptures referring to grace. Your life will be transformed when Christ gives you a revelation of what grace truly means.

Prayer: Father, we are so thankful for Your grace! Lord, we know the answer to all our problems lies in the cross. Thank You that my bad days are still good because I have You. You work everything out for my good.

Day 38

Focus Scripture: "For this reason I say to you, do not be worried about your life, as to what you will eat or what you will drink; nor for your body, as to what you will put on. Is not life more than food, and the body more than clothing? Look at the birds of the air, that they do not sow, nor reap nor gather into barns, and yet your heavenly Father feeds them. Are you not worth much more than they? And who of you by being worried can add a single hour to his life?" Matthew 6:25–27

Scripture Reference: Matthew 6

Anxiety

Anxiety . . . That very word clutches at our heart and makes us bend to its whims.

Nobody wants to live with anxiety. It's definitely not a part of our hopes and dreams for adulthood. So many of us suffer with this consuming fear. Pharmaceutical companies would love to persuade you that they have the magic bullet to deal with anxiety.

What people do not understand is that there are normally two options to get free (and one of those options is a Band–Aid). The first option is medication, but who wants to live on medication their whole life? What if you miss a dose? You could end up anxious about your anxiety medication. How can you walk-out true Biblical victory when your salvation is found anywhere but Jesus?

The Biblical answer to conquer anxiety might seem counterintuitive. "Do not be anxious about anything, but in everything, by prayer and supplication with thanksgiving, let your requests be made known to God. And the peace of God, which surpasses all understanding, will guard your hearts and minds in Christ Jesus." Philippians 4:6–7

The way to cure anxiety is to ask for forgiveness for taking on something that was never yours to take, and praise the Lord for His salvation from anxiety. You get anxious about things you cannot control, but that's the thing—you cannot control anything.

Living in a state of anxiety does nothing to fix any problem. You, instead, have to deliver your trust back to God and ask for forgiveness for shouldering something that was never your problem.

You are not strong enough to bear this burden—no one is. We have to lay our problems down and not pick them up again. "The steadfast of mind You will keep in perfect peace, because he trusts in You." Isaiah 26:3

The world is always going to have horrible people and horrible situations, but your worrying about them will not change one thing. When we surrender, God can move through us.

Question: Are you ready to lay anxiety down?

Application: Start a dialogue with the Lord. Ask forgiveness for taking things on that weren't yours to take and then lay them down. The Lord is mighty to save. Trust Him! Proclaim truth every time you feel anxious. Here are some truths.
- Those who put their trust in the Lord will never be ashamed (Psalms 25:3).
- God has created me to be free (Romans 8:2).
- This temporary light affliction is building in me an eternal weight of glory (2 Corinthians 4:17).
- No weapon formed against me shall triumph (Isaiah 54:17).
- God is love and love never fails. Perfect love casts out all fear (1 John 4:18).

Prayer: Thank you, Lord, that you are trustworthy! I am so grateful that I can lay down all my burdens. You bore all my problems . . . Yes, it is past tense because it is already done! I cannot live like this anymore. It has eaten at me for too long. I give it back to You. I repent for trying in my

own strength. I want You to invade every area of my life. I give this problem back to You, and I release Kingdom into the situation.

Day 39

Focus Scripture: "But thanks be to God, who always leads us in triumph in Christ, and manifests through us the sweet aroma of the knowledge of Him in every place." 2 Corinthians 2:14

Scripture Reading: 2 Corinthians 2

Onward

The only way "out" is through . . . This works spiritually, emotionally and physically. Stop looking for a way out of your problem, and resolve in your heart to walk through this, trusting the Lord.

As humans, we have been programmed to self–preserve. This programming can actually do more harm than good if it gets in the way of our trusting God. He always has the strategy to give us victory over our situations. His plan is always better than our futile attempts at rescuing ourselves.

We want to be known as overcomers. "And they overcame him because of the blood of the Lamb and because of the word of their testimony, and they did not love their life even when faced with death" (Revelation 12:11).

A few months ago, I had a dream. I was walking to a friend's house with my kids. We had to cross a large body of water. Straight down the middle, there was a pathway about a car-length wide. It sat dry but right on the water.

I had my double stroller halfway across the lake when all of the sudden all these alligators got out of the water and were lying on the path. They surrounded me before and behind. They were extremely irritable and trying to fight each other viciously. I was terrified. There was no way out.

Almost as if my legs took over, I started walking. Each step I took, the alligator in front of me slid off and got in behind me. This went on until I crossed safely to the other side.

The threat was undeniably real and didn't get any easier, but I knew stopping wasn't an option.

I often say there is no "instant health or weight loss " pill. Everything worth having must be grabbed, contended for, and cultivated. This may be the most difficult season you have ever been through, but you have to keep walking. God doesn't fail—TRUST. We do not walk by sight. We walk by faith. The only way out is through.

Question: Do you trust that the Lord plans to lead you into triumph?

Application: Every morning, wake up and say, "Thank you, Jesus, for your goodness! I am placing You first in my life. I look forward to walking this day out with You!"

Prayer: Dear Heavenly Father, thank You that You are mighty to save. Thank You that as we dwell in the secret place You give us the strategy for whatever we are facing. Lord, we walk forward in full trust in You. We know You are capable of the miraculous when it comes to our life. We thank You for Your protection.

Day 40

Focus Scripture: "Behold, I am going to send you Elijah the prophet before the coming of the great and terrible day of the LORD. He will restore the hearts of the fathers to their children and the hearts of the children to their fathers, so that I will not come and smite the land with a curse." Malachi 4:5–6

Platform

The world can seem so vile and dark, but God has the winning strategy. God's plan is to restore hearts. Many lives will change because they meet people walking in their mantle of "Father" or "Mother" or "Son of God." Children will have their hearts restored towards their parents.

The family unit will be so strong that it starts reaching out and swallowing other families into the bond. The world will change when we start allowing the Lord to work through us and love those with an "orphan spirit." Our calling to "mother" our kids has the ability to change history.

"Pure and undefiled religion in the sight of our God and Father is this: to visit orphans and widows in their distress, and to keep oneself unstained by the world" (James 1:27).

One of the most important reasons, we teach our kids from the place that we have grown. We have to grow in our relationship with Christ because our kids learn about the Lord from us, and they start on the same level as us.

My daughter is three. She wants to chase people down and pray for their "boo-boo's". She has personally witnessed Christ's healing power in her life, and she wants to share it with the world. Sometimes the easiest way to get her out of the house is to tell her she can pray for someone.

I often hear her quietly praying for herself. (She has her clumsy moments), and I am overwhelmed with God's goodness. I love that my child gets that.

I'm not concerned if she can recognize her letters at the age of one. I'm concerned that she knows Jesus is always there for her. I'm not concerned if she is on track with her peers. I'm concerned that she is on track with her potential in Christ. The Bible warns us that this life is a mere blip and does not end when we die. It is my job to prepare her for what comes next.

Goals are important. When your vision is right, everything falls into place. By making Christ the priority, I've noticed my child grows smarter each day almost without effort. There will be a time when we sit down and learn everything, but today, I'm focusing on character and integrity.

No matter what she does in this life, these are the building blocks for the highest success.

I hope I can inspire you to run this race with your kids. Let them truly encounter Jesus. Their lives will never be the same. Show them His goodness, and they will rely on it the rest of their days. You are raising a game changer.

Question: What does raising a "game changer" look like to you?

Application: Be bold for your kids' sake. They are modeling everything they know after you. The Kingdom of Heaven is violent and the violent take it by force (Matthew 11:12). Do not sell yourself short! You have amazing potential in the Lord. Let Him be King in your life!

Prayer: Lord, thank You for the privilege of raising my kids in the truth. Help me to convey the need for a lasting relationship with You! I am so grateful for the gifts You

have given me. Help me to be bold. I want to see my children grow up in the knowledge of You!

Find more at www.laneigeunleashed.com

Acknowledgements

First and foremost, this is Jesus' book. I hang on every word of encouragement He has for me. I'm grateful for His love.

I would like to thank my husband. Without his support, advice and encouragement, this book would never have been published.

I would like to thank my mom. Her dedication to seeking God's face and her discipline have molded me into the person I am today.

Also, my dad—His faithfulness has taught me so much.

I'm thankful for my kids. They play a huge role in my growth.

I would also like to thank my Nana for never doing the easy thing but always striving to do the right thing. I have come from a long line of strong women.

Nicolette, thank you for our late night chats about unconditional love and introducing me to the song "La Neige Au Sahara." I love your friendship.

Thank you, Caryl McAdoo, for showing me the ropes. I can't imagine knowing a more generous and supportive person.

Thank you, Lenda Selph. I appreciate you wading through my manuscript and helping me make sense of it all. You truly are a blessing from God.

Thank you to all my ladies at La Neige au Sahara— my workout group. You each have encouraged me, stood by me and taught me so much. I feel blessed to know so many wonderful people, many I haven't mentioned. There just isn't enough room.

67608740R00102

Made in the USA
Lexington, KY
16 September 2017